IMAGES
of Aviation

HOUSTON AVIATION

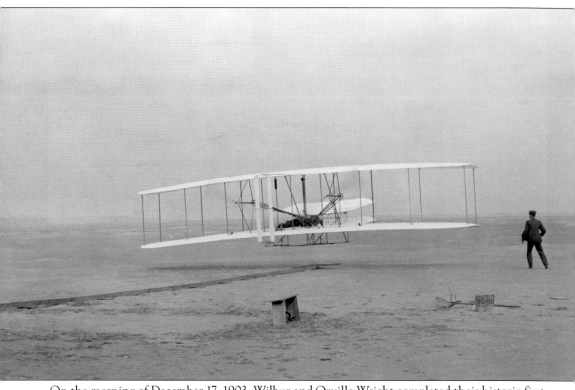

On the morning of December 17, 1903, Wilbur and Orville Wright completed their historic first controlled heavier-than-air powered flights at Kill Devil Hills in the Kitty Hawk area of the North Carolina Outer Banks. A telegram sent later that day by the brothers to their father read: "Success four flights thursday morning all against twenty one mile wind started from Level with engine power alone average speed through air thirty one miles longest flight 57 seconds inform Press home Christmas." (Library of Congress.)

ON THE COVER: In 1940, the City of Houston opened its newest terminal (now the 1940 Air Terminal Museum) at the Houston Municipal Airport. The Douglas DC-3 pictured in Pioneer livery was the primary aircraft used by the airlines serving Houston in the 1940s. In the 50 years following its introduction in 1935, over 350 civilian airlines and corporations in the United States had used the DC-3. Pioneer was one of the various airlines that operated out of Houston in the 1940s. Started as Essair, it changed its name to Pioneer Airlines only to be bought out by Continental Airlines in 1955. United Airlines and Continental then merged in 2010. (Briscoe Center for American History, University of Texas.)

IMAGES
of Aviation

HOUSTON AVIATION

The 1940 Air Terminal Museum

Larry Karson, editor

ARCADIA
PUBLISHING

Published by Arcadia Publishing
Charleston, South Carolina

Printed in the United States of America

Library of Congress Control Number: 2015903574

For all general information, please contact Arcadia Publishing:
Telephone 843-853-2070
Fax 843-853-0044
E-mail sales@arcadiapublishing.com
For customer service and orders:
Toll-Free 1-888-313-2665

Visit us on the Internet at www.arcadiapublishing.com

Dedicated to Captain A.J. High, former chairman of the board and chief executive officer of the 1940 Air Terminal Museum—Our leader, our mentor, and our friend.

CONTENTS

ACKNOWLEDGMENTS

Many people contribute to a work of this type, but first among many for this book is John L. Graves, former president and a current director of the 1940 Air Terminal Museum. John's vision of a representative work centered on the historical museum became the foundation of this book. With the energy and support of his fellow directors, in particular Eric Speck, who best articulated the concept of this work as an extension of the educational mission of the museum to "promote and preserve the rich aeronautical heritage of Houston and Southeast Texas," John's vision was realized.

Story Sloane gave much of his time, his expertise, and his collection of historical aviation photographs to the project. I have no doubt that this book would never have moved past its formative stage without his assistance and guidance.

The archivists and staff of numerous library collections offered content and their time including Gregory Yerke of the University of Houston Libraries; Joyce Kleimann of the Hitchcock Public Library; Tim Ronk of the Houston Metropolitan Research Center; Kimberly Johnson of the Texas Woman's University Libraries; Travis Bible of the Rosenberg Library, Galveston; Don Carleton, Amy Bowman, and Aryn Glazier of the Dolph Briscoe Center of American History, University of Texas at Austin; Steve Hersh of the Richter Library of the University of Miami; Tom Blake at the Boston Public Library; Dawn Hugh at HistoryMiami; and Jean Gates of the Texas Military Forces Museum. These collections allow us to better understand our history, and without them, much would easily be forgotten in the headlong rush to an unknown future. What they offer us is a window to that future, if suitably viewed.

Amy Rogers, the 1940 Air Terminal Museum's managing director, was always available to address the paperwork, Michael Bludworth committed to reviewing the photographs and captions for accuracy (his expertise was invaluable), and Geoffery Scripture was always gracious and patient in his assistance in accessing the museum's archives and displays.

Ginny Rasmussen, Laura Bruns, and Jim Kempert chaperoned this project at Arcadia Publishing.

The University of Houston–Downtown was kind enough to allow the time to work on this project for the 1940 Air Terminal Museum, and finally, the never-ending support of my wife, Cindy, kept the "gremlins" at bay for many a day.

My thanks go to all and my love to one.

—Larry Karson, editor

If any inaccuracies are noticed, please forward corrections to 1940ATM@gmail.com for appropriate amendment of later editions.

INTRODUCTION

Since shortly after the first airplane flew over south Houston in 1910, the business community, the military, and eventually, the developing commercial airline industry have been in a symbiotic relationship that has contributed to the continuing growth and development of aviation in Houston and Southeast Texas.

With the start of war in Europe in 1914, the business community's influence led to the establishment of Ellington Field as an Army base three years later. As part of the original purchase arrangement, the Houston Chamber of Commerce agreed to deposit $25,000 in a local bank to be spent toward deepening and straightening a local bayou to allow the new airfield to effectively drain, as it was underwater when originally purchased. With over 5,000 personnel on the airfield when the Great War ended, federal dollars for construction and salaries had guaranteed economic development to the greater metropolitan community well beyond that original investment in drainage.

By the 1920s, American business recognized the success—and profitability—of the US Air Mail Service, and Congress authorized the creation of subsidized commercial airmail routes through the passage of the Air Mail Act of 1925 (the Kelly Act) followed by the Air Commerce Act of 1926. With guaranteed government funding, a variety of business interests obtained Contract Air Mail routes and initiated nationwide airmail service, including to Houston and Galveston. By 1932, Walter Brown, the postmaster general under the Hoover administration, had used his authority in granting airmail contracts to create an integrated, transcontinental commercial airline system. By eventually offering a subsidy based on available space per mile, commercial carriers were compensated by the capacity of their aircraft, contributing to the development of larger passenger planes. The postal contracts offered the opportunity for the airlines to establish a level of financial stability that allowed for both technical development and industry growth. Pan American Airways, one of many airlines that serviced Houston over the years, alone received $47.2 million between 1929 and 1940 in airmail subsidies. As the airline historian R.E.G. Davies stated, "Postmaster General Brown, in effect, created the necessary environment to stimulate the development of a new breed of aircraft. He went into office with a dream of an airline network to surpass the world. When he left office, this had been achieved handsomely."

Along with the growth in the airlines, cities across the country, including Houston, developed modern airports to attract the aviation industry. Houston bought a private airfield south of the city and developed it as the Houston Municipal Airport, now known as William P. Hobby Airport. The city turned to the federal government, through a Works Progress Administration (WPA) project, to drain, grade, and build the original runways. When Capt. Eddie Rickenbacker, the president of Eastern Air Lines, later deemed the crushed shell runways unacceptable for DC-3 traffic, the City of Houston paved them. As each terminal became outmoded, a new facility was constructed, including the 1940 Art Deco–influenced terminal and the later twin-concourse terminal.

By 1938, the federal government assumed responsibility for building a regulatory and economic structure that allowed the airline industry to stay profitable for the next 40 years. With the continued use of mail subsidies (providing 30 percent of local service revenues as late as the mid-1960s) and with limited competition, market expansion became financially viable, attracting more resources as the industry developed at a remarkably fast pace.

Houston's own economic engine has been primarily fueled by oil since the Spindletop boom of 1901, and oil entrepreneurs here recognized the potential of aircraft. As early as the 1920s, the burgeoning Houston energy industry realized the value and utility of aircraft as business tools. Houston became an epicenter for modern business aviation, with companies such as Texaco and Humble using aircraft to travel the vast distances between the oil fields and the oil suites. At least two oil magnates invested in an aircraft manufacturing company at one point; the oil industry would have a close affiliation with aviation beyond simply being a source of fuel for the nation's air fleet. Howard Hughes, possibly the most famous of Houston's billionaires, started in the oil field services industry as the owner of Hughes Tool Company. Hughes went on to control two airlines (Trans World Airlines and, later, Hughes Airwest), to develop and manufacture aircraft, and to set a variety of flight records—including an around-the-world record in 1938. After World War II, Hughes turned to helicopter manufacturing while also becoming a major defense contractor in later years.

Though Ellington had closed shortly after the World War I armistice, military aviation continued locally with the 111th Observation Squadron of the Air National Guard and at Fort Crockett, Galveston, home to the 3rd Attack Group until the mid-1930s. With the advent of World War II, the economic expansion of Houston continued when Ellington Field reopened as a training facility for the Army Air Corps.

For the airlines, profit was all but guaranteed, as many flights were fully booked with passengers traveling on government-funded vouchers. By 1944, Houston Municipal Airport saw 7,300 flights with 85,000 passengers move through in one year. Flights almost doubled to 13,000 with 136,000 passengers a year later. Fixed-base operators held government contracts to train aviators in Houston and elsewhere for the war effort. With demobilization, those same pilots became the trained cadre of flight crews for commercial carriers in the postwar years.

In the 1950s, federal subsidies supported the development and growth of local air service throughout Texas. Those subsidies offered individuals living in smaller communities across the state the opportunity to fly in a DC-3 from their local airfield instead of first driving 100 miles or more to a major city's airport.

In 1962, Pres. John F. Kennedy gave what became known as the "Moon speech" at Rice University where he stated, "We choose to go to the moon. We choose to go to the moon in this decade." During the same speech, the president also referred to the future Manned Spaceflight Center in Houston, saying that it would "double the number of scientists and engineers in this area, to increase its outlays for salaries and expenses to $60 million a year; to invest some $200 million in plant and laboratory facilities; and to direct or contract for new space efforts over $1 billion from this Center in this City." In effectively arguing for the center to be located in Southeast Texas, its economic advantages had been recognized in the late 1950s and early 1960s by both the Houston business community and by the politicians of Texas, including Congressional representative Albert Thomas and then Texas senator Lyndon Baines Johnson. Within the promised decade, Neil Armstrong spoke to the world: "Houston, Tranquility Base here. The *Eagle* has landed."

By 2013, Houston had unveiled a concept for a spaceport, to be located at Ellington, now a public and military joint-use airport, to serve as an economic generator as well as to enhance Houston's reputation as a leader in the aerospace industry. Within the year, the city partnered with a private corporation to study the feasibility of landing the company's spacecraft at the newly proposed spaceport.

The future Houston Spaceport epitomizes the historical triptych of Houston business, military, and commercial aviation that all but defines Southeast Texas aviation, extending its reach even further into the Space Age. This pictorial work celebrates the "golden age" of that history.

One

EARLY AVIATION

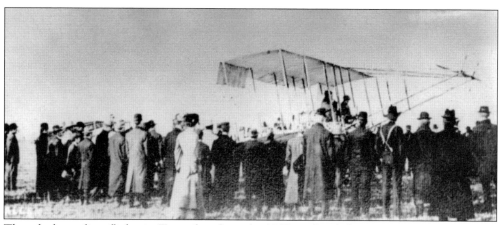

Though the earliest flights in Texas date from the 1860s with exhibitionists operating balloons, at least one individual, Jacob Brodbeck, is alleged to have designed and operated an airplane powered by coiled springs in the same decade. It would be another 50 years before the first airplane actually took to the skies in Houston. Frenchman Louis Paulhan would have that honor, drawing thousands to witness the event. (University of Houston.)

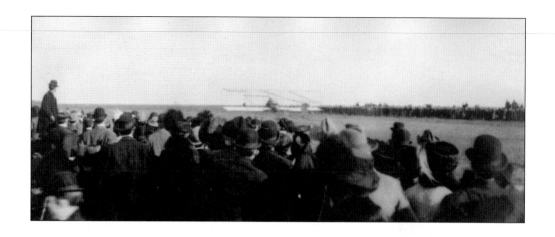

Louis Paulhan, traveling across the United States from the Los Angeles International Air Meet, arrived in Houston in February 1910 after performing in aviation exhibitions in Salt Lake City, Denver, and New Orleans. The *Houston Post* and the Western Land Company had commissioned Paulhan, for a $20,000 fee, to perform a flying exhibition approximately eight miles southeast of downtown Houston where Western had an interest in showing off its new housing development in South Houston. On the morning of Friday, February 18, 1910, after having cancelled the previous day's flights due to excessively high winds that could damage his airplanes—he was traveling with a variety of airframes—Paulhan finally entertained the Houston throng. (Above, University of Houston; below, Story Sloane's Gallery.)

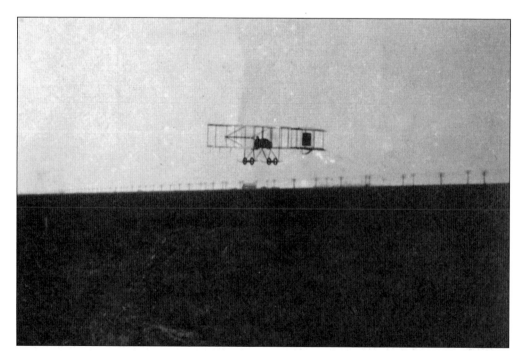

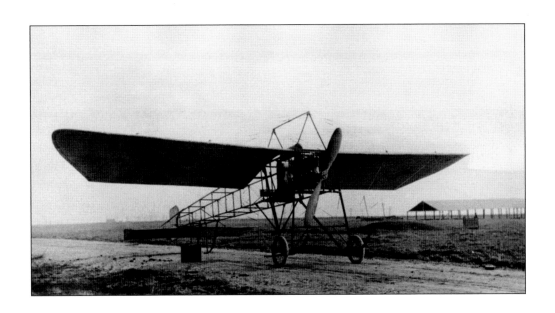

Individuals who saw the Paulhan exhibition in Houston included L.L. "Shorty" Walker, L.F. Smith, and Guy C. Hahn. Walker's first aircraft, shown immediately after delivery to the South Houston airfield in early 1910, was a Bleriot design powered by an American-built Kemp "Grey Eagle" four-cylinder in-line air-cooled 40-horsepower engine. Walker is believed to be the first Houstonian to pilot an aircraft. He modified his original Bleriot-design airframe by adding dual wheels with a skid between each set. The wheels aided in rough field operations, and the skids both protected the propeller and guarded against the aircraft nosing over. Walker later attempted to fly to Galveston, but after flying southwest to La Marque he returned to South Houston, as the distance over the bay looked too great. (Both, University of Houston.)

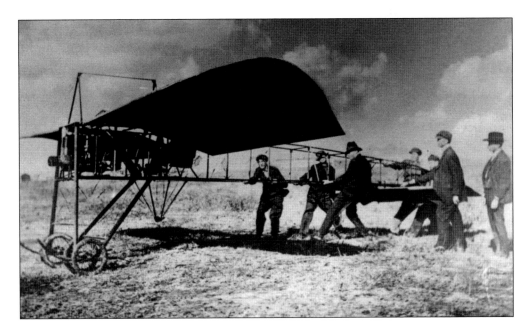

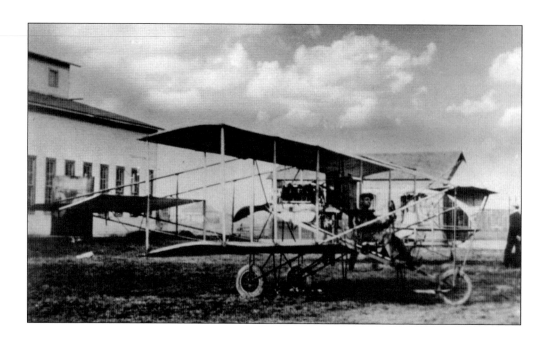

L.L. Walker operated a Curtiss Pusher–type airplane out of the South Houston airfield. The aircraft, purchased from Fred DeKor, crashed later after a wheel broke on takeoff. L.L. Smith and Guy Hahn also built numerous aircraft themselves in South Houston, including another variation of the Curtiss Pusher airplane, shown below. By the end of 1911, the local Cotton Carnival included an air show of five locally constructed aircraft. The Curtiss-designed aircraft were a primary competitor to the Wright brothers, leading to what later became known as the "Patent Wars," effectively limiting the early development of aviation manufacturing in the United States. (Above, University of Houston; below, MSS253-050, Houston Public Library, HMRC.)

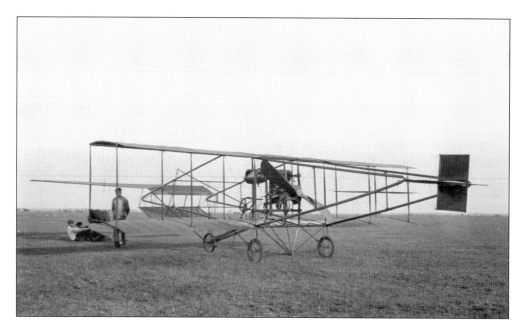

On January 27, 1911, the Moisant International Aviators air show arrived in Houston. John Moisant and his brother Alfred had formed the exhibition group the previous year, recruiting pilots at Belmont Park air races. John's fame came from being the first pilot to cross the English Channel with a passenger (his mechanic) on August 17, 1910. Invited to the Gordon Bennett Race to compete for the International Aviation Cup, he came in second but achieved a first in the Statue of Liberty event, where pilots flew from Belmont Park to the statue and back. John Moisant died in an aircraft accident one month prior to the Houston exhibition while the show was visiting New Orleans. Pictured below are, from left to right, Joseph Seymour (sitting); John Frisbie (sitting); Rene Simon, "the flying fool," (sitting); Edmond Audemars (standing), Rene Barrier (sitting); Roland Garros (sitting); general manager Peter Young (sitting); and Charles Hamilton (standing). (Both, Story Sloane's Gallery.)

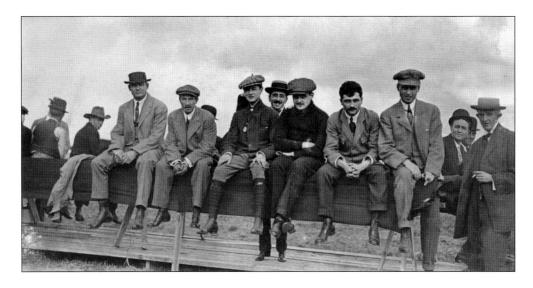

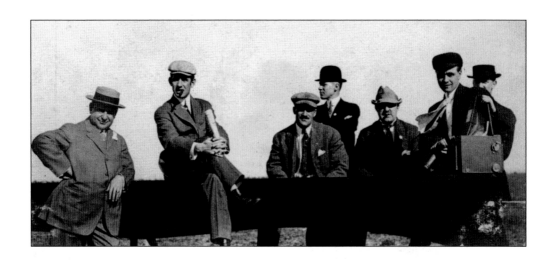

John Winter photographed spectators with Bert Blessington, *Houston Post* photographer and cartoonist, at right. Winter captured many of these pictures of the air show. Edmond Audemars's Demoiselle and two Bleriots are shown below. Audemars, from Switzerland, was advertised as the "smallest aviator in the world," who flew "the smallest and most dangerous aeroplane in the world." Audemars purportedly retired from flying upon the death of his air show associate and close friend Roland Garros. Louis Bleriot, the French aviator, manufacturer, and the designer of a variety of aircraft such as the Bleriot XI, was the first to cross the English Channel (1909) in a heavier-than-air aircraft and years later greeted Charles Lindbergh when he landed in France after his solo flight across the Atlantic. (Both, Story Sloane's Gallery.)

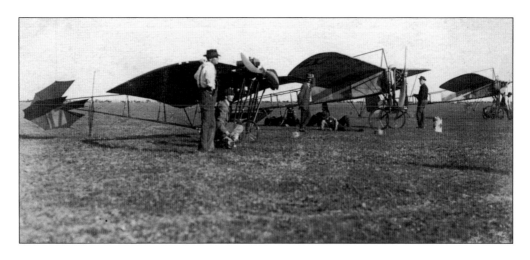

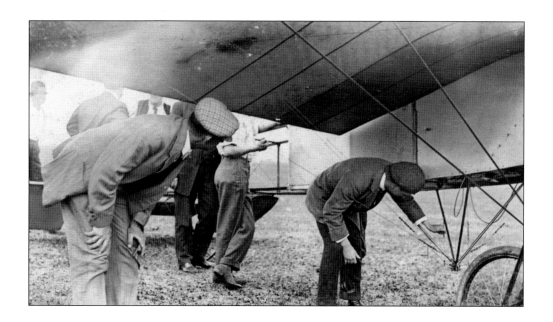

In the initial years of aviation, as today, the preflight inspection of aircraft such as the Bleriot shown above was critical for safe operation. John Moisant had earlier remarked that aluminum airplanes were the future of aviation, believing that the then current construction methods were unsafe. "Their construction is too frail and there are too many wires and the wings are too flimsy," said Moisant. Alberto Santos-Dumont offered his design of the diminutive Demoiselle ("Damselfly"), shown below, to the public for free, intending to advance aeronautics worldwide. In June 1910, *Popular Mechanics* published the plans for the mechanically inclined interested in building one. (Both, Story Sloane's Gallery.)

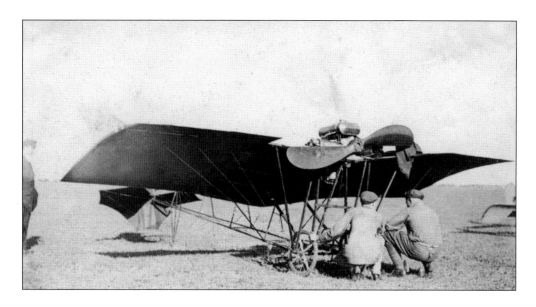

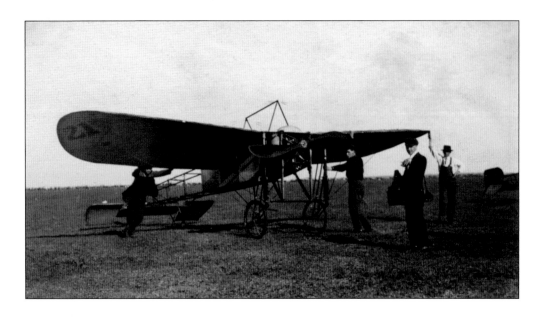

A Bleriot (shown above with "21" on the underside of its wing) had been purchased by John Moisant for $10,000 at the aviation meet at Belmont Park less than three months earlier to allow him to compete in a race from Belmont Park to the Statue of Liberty and back after having damaged his own aircraft earlier. The airframe became known as the *Statue of Liberty* machine after Moisant's victory, winning a prize of $10,000. *Houston Post* photographer Bert Blessington is shown with the aircraft. Rene Simon, preparing for takeoff, was one of three Frenchmen flying with the International Aviators, along with Rene Barrier and Roland Garros. Simon, marketed as the "fool flyer" for his low-level maneuvers, went on to serve with French military aviation during World War I. (Both, Story Sloane's Gallery.)

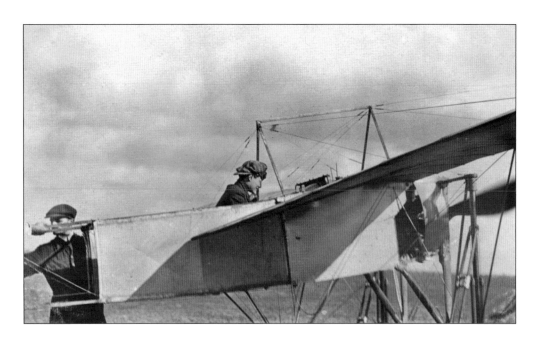

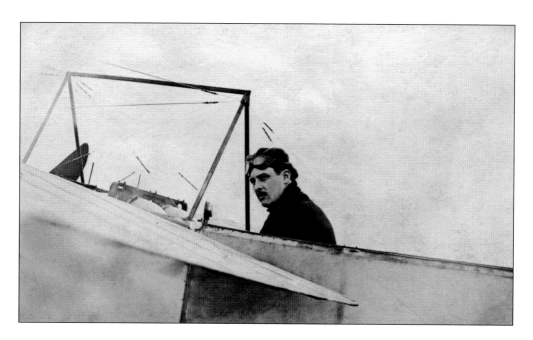

Rene Barrier, shown above in a Bleriot, would later die in a flying accident in the 1920s. His fellow Frenchman Roland Garros held the world altitude record at one point. Garros later served in the French military as a pilot. He was captured by German troops after an emergency landing behind enemy lines, but escaped after almost three years of captivity and took to the air once again, only to be shot down and killed shortly before the armistice. Below, a Bleriot is seen flying over the aviation field. Since its original development with a 25-horsepower Anzani engine, later Bleriot airframes were upgraded with more potent power plants including the Gnome 80-horsepower air-cooled rotary engine. The *Statue of Liberty* Bleriot had a 50-horsepower motor while others carried 100-horsepower motors. (Both, Story Sloane's Gallery.)

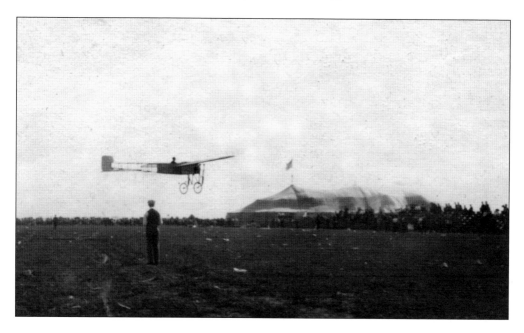

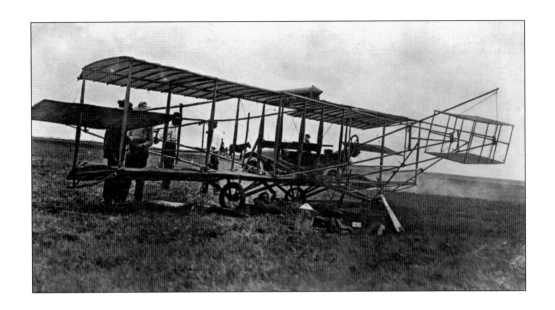

Charles Hamilton can be seen above taking a nap under his aircraft. He had come with his Curtiss-type "Hamiltonian," mounted with a 110-horsepower Christie motor. Hamilton had previously flown balloons and dirigibles prior to airplanes, becoming one of the best known of the new aviators in America. Learning to fly under the tutelage of Glenn Curtis, he won a $10,000 prize for the first round-trip flight between New York and Philadelphia in 1910. Unlike many of his peers in the Moisant air show, such as John Frisbie, instead of an aviation accident or combat, tuberculosis took his life in 1914 at the age of 28. (Both, Story Sloane's Gallery.)

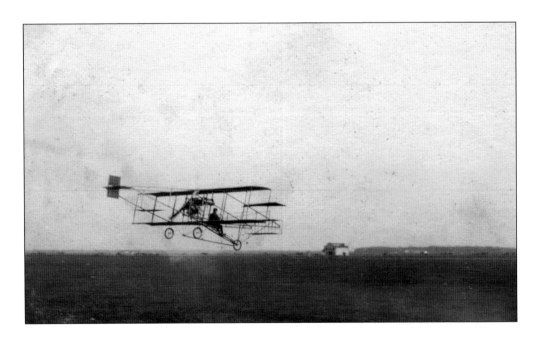

The International Aviators continued onward from Houston with air shows in San Antonio, El Paso, Monterrey, Mexico City, and Vera Cruz, traveling by train with four airplane cars, two baggage cars, and two Pullmans to carry the aviators, "mechancians," canvassmen, and roustabouts. The final show was in Havana, Cuba, before the aviators disbanded. While in El Paso, Rene Simon flew a reconnaissance flight over Mexican territory at Juarez at the behest of the US Army. (Story Sloane's Gallery.)

The following year, Hamilton returned to Texas for an exhibition in Galveston, where he raced his plane against an automobile on the Galveston beach in a demonstration of speed. Auto and aircraft races were common on the exhibition circuit, with some early aviators having gravitated from automobiles to the new and intriguing aircraft. (Library of Congress.)

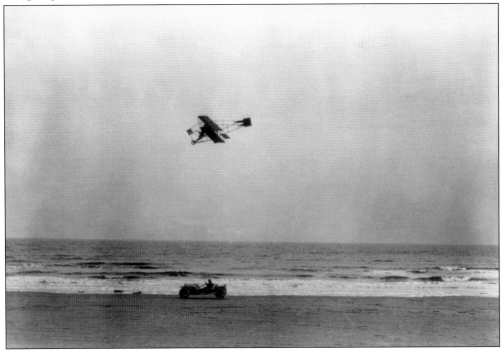

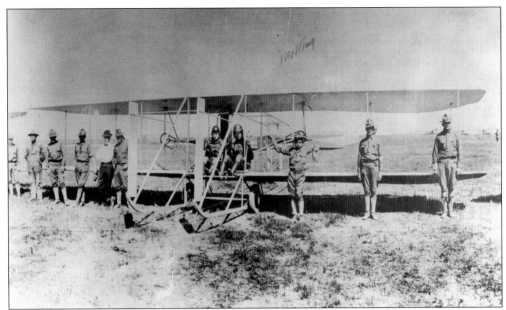

In 1913, the Army transferred Signal Corps aviators to Texas City, Texas, (on Galveston Bay) in response to possible hostilities on the Mexican border. The newly created unit, the 1st Aero Squadron (Provisional), would lose its provisional status by the end of the year. The squadron originally consisted of nine airplanes, nine officers, and 51 enlisted personnel. Their aircraft included at least one Wright C, designated as "Signal Corps No. 11." The image above, from a panoramic photograph of six aircraft, has a notation, possibly referring to another aircraft in the original photograph, labeling one of the operators as "Milling" but at least one Air Force reference identifies Lt. Fred Seydel and Lt. W.C. "Bill" Sherman at the controls. Master Sgt. Carl T. Hale, at the time a first class private assigned to the 1st Aero Squadron, took the diagramed photograph below. (Above, Air Force Historical Research Agency; below, the National Museum of the Air Force.)

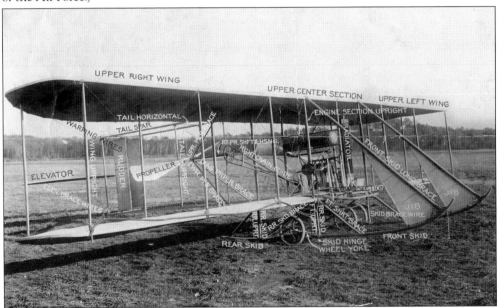

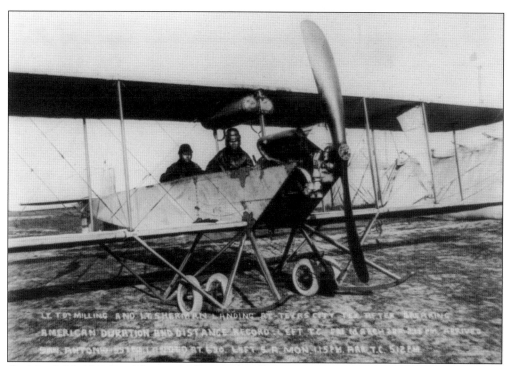

On March 28, 1913, Lts. Thomas Milling and William "Bill" Sherman flew a Burgess Model H to San Antonio and back, setting an endurance and distance record while also creating a 10-foot-long aerial map of the terrain observed during the journey. The 1st Aero also operated at least one Wright B on floats while at Texas City. By the end of the year, the squadron was transferred to North Island, San Diego, with only a small detachment assigned to Fort Crockett on Galveston Island. Milling and Sherman were both graduates of the US Military Academy at West Point. (Above, Library of Congress; below, Air Force Historical Research Agency.)

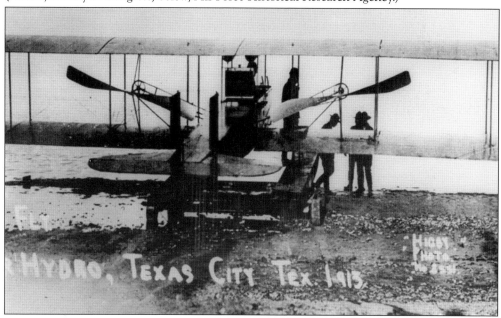

When the war in Europe started in August 1914, the US Army still failed to fully grasp the potential of military aviation, yet within two years, the nation had also entered the war and recognized the need for numerous training facilities to accommodate the demand for aviation resources. The government purchased 1,280 acres of land southeast of Houston. By November 1917, the field was complete and the 120th Aero Squadron arrived from Kelly Field (San Antonio) along with 10 Curtiss JN-4s. In 1918, the first-known modification of an Army aircraft to serve as an ambulance was credited to two officers at Gerstner Field, Lake Charles, Louisiana. Within the year, military airfields across the country, including Ellington, had been directed to construct one. A later aircraft, a JN-4H, was also modified at Ellington with an improved design. (Above, Texas Military Forces Museum; below, MSS253-059, Houston Public Library, HMRC.)

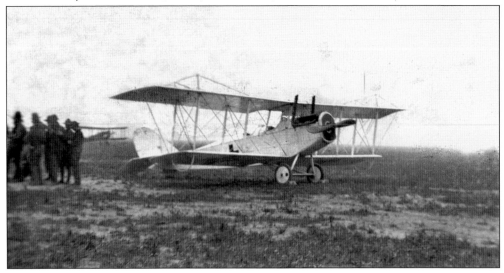

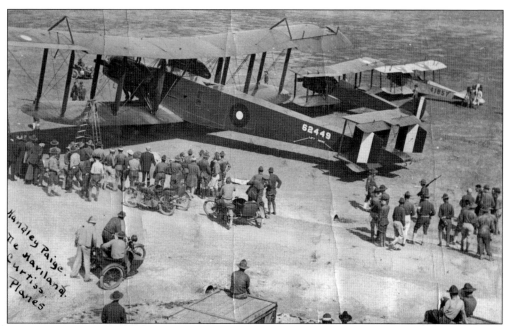

The British developed the Handley Page 0/400 bomber as an offensive weapon with the intent of being "a bloody paralyzer." The Standard Aircraft Corporation built the 0/400 in the United States under license, eventually completing 107 out of the original order of 1,500 before the cessation of hostilities. Powered by twin 350-horsepower Liberty engines, there were only four reportedly still in commission by mid-1919. The insignia on the fuselage is the American roundel of white, blue, and red (from the center outward) with the tail markings being blue, white, and red running forward to aft. These roundels assisted Allies in identifying friend from foe, as the use of the American star insignia was similar to the German white-bordered cross when seen from a distance. The other two aircraft are a De Havilland DH-4 and the ubiquitous Curtiss JN-4. The motorcycles are Harley-Davidsons. (Both, Texas Military Forces Museum.)

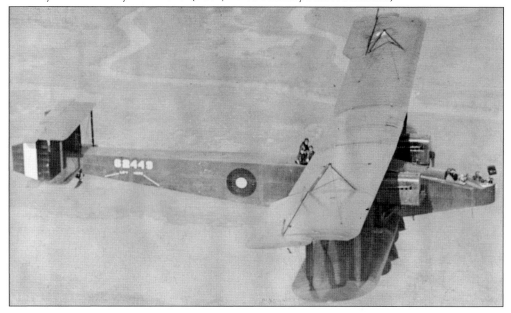

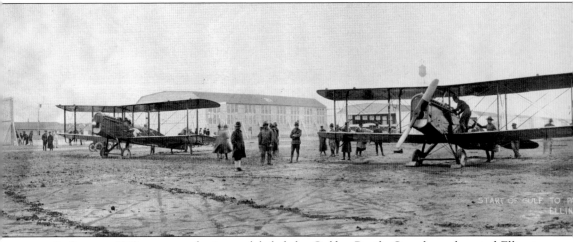

In January 1919, a group of aviators, labeled the Gulf-to-Pacific Squadron, departed Ellington Field on a 3,300-mile round-trip endurance flight. Flying from Houston to California, the flight, led by 1st Lt. R.O. Searle, claimed to be the first trip across the Grand Canyon by air, with one of the aircraft actually flying down the Colorado River 600 feet below the canyon's rim. Others in the flight included Lts. E.D. Jones, Rick Nelson, Howard Birkett, and E.L. Bilheimer, and Sgt.

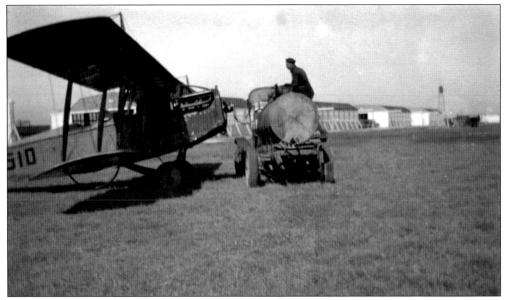

Critical to operating any aircraft is a consistent source of fuel and its timely delivery. A century later, specially designed tanker trucks continue to transport fuel to the flight line at most airfields and airports. (Larry Karson.)

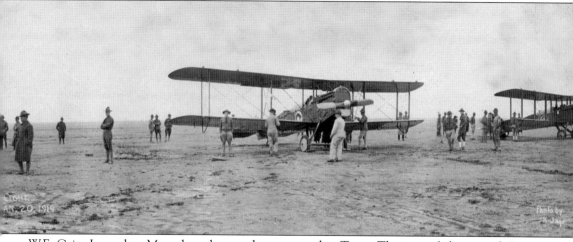

W.E. Cain. It was late May when the squadron returned to Texas. The type of planes used, De Havilland DH-4s, were the only US-built aircraft to see combat during World War I. Almost 5,000 were built and saw a variety of uses including two years with the US Army Border Air Patrol from mid-1919 through 1921. (Texas Military Forces Museum.)

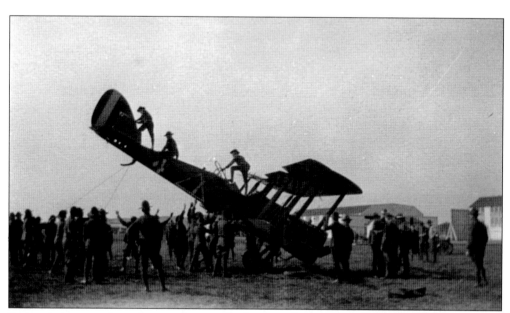

Early aviation was a hazardous profession, whether over the front lines in Europe or flying at home. Of the almost 700 American aviation fatalities in World War I, 75 percent died in accidents, most while in flight training stateside. (Larry Karson.)

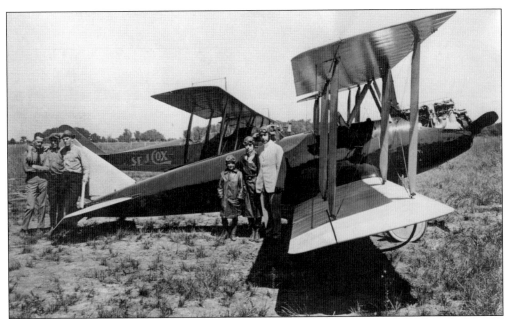

S.E.J. Cox, a Houston oil stock marketer, bought two Curtiss Orioles for business. The Orioles carried two passengers and a pilot, operating at a cruising speed of approximately 70 miles per hour with a range slightly less than 600 miles. Pictured in the center is S.E.J. Cox, with his wife, Nellie, and their nine-year-old son, Seymour. Cox eventually served time in Leavenworth Federal Penitentiary for using the mails to defraud investors out of more than $1 million. In 1919, Hal C. Block, a former military aviator, flew one of the Orioles from Houston to New York with Nellie and Seymour Cox as passengers. Leaving Houston on September 28, they traveled north to Dallas, then on to Arkansas, St. Louis, Dayton, Cleveland, and Binghamton, New York, arriving in New York City 10 days (and two weather delays) after leaving Houston. (Both, University of Houston.)

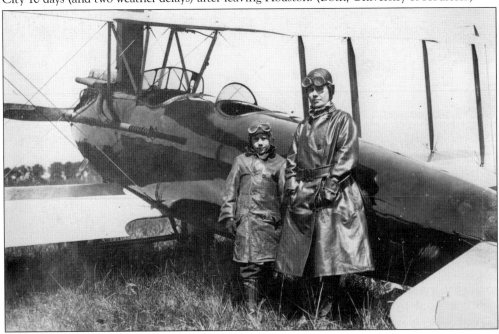

Two

THE 1920S

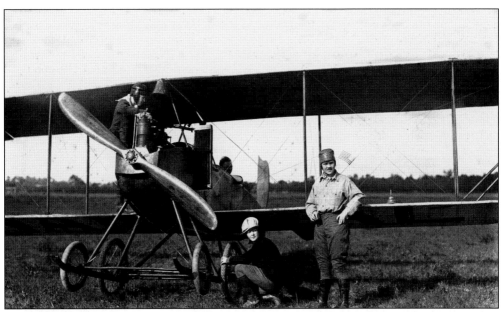

The World War I labor shortage offered women the opportunity to enter the workforce in nontraditional roles while the suffragette movement successfully challenged gender stereotypes in various fields including aviation. Katherine and Marjorie Stinson, for example, instructed fledging pilots in San Antonio. Brother Eddie Stinson, later the founder of Stinson Aircraft, partnered with Bob Shank in Houston to form the National School of Flying. The word "Hirondelle" is painted on the off-side engine cowling. (MSS0253-056, Houston Public Library, HMRC.)

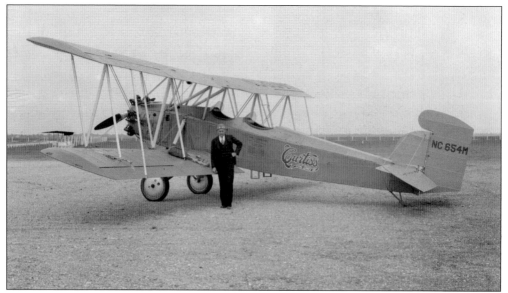

As aviation grew after the war, numerous commercial aviation businesses developed for a new generation of pilots, with the Curtiss Flying Service being one of the more nationally famous businesses, thanks in no small part to its pioneering namesake, Glenn Curtiss. Providing sales, service, training, and transportation services, it was a full-service operation at many airfields. The Houston office even handled crop dusting for local cotton farmers dealing with boll weevils. Above, a parachute harness can be seen on the wing of a Curtiss Fledgling, which was primarily powered by a Curtiss Challenger engine. Originally developed in the mid-1920s for the Navy as a trainer, approximately 100 were manufactured for civilian use. Below, one of aviation's many roles included opening otherwise isolated areas to hunting and fishing, a service still provided in numerous remote areas of the United States and Canada. (Both, Story Sloane's Gallery.)

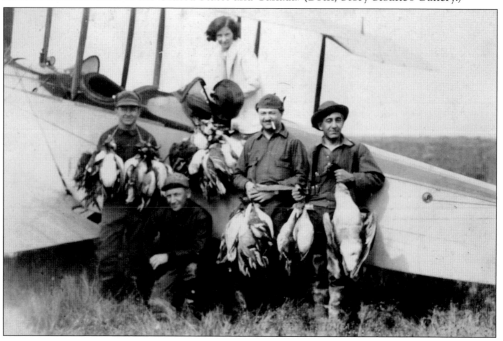

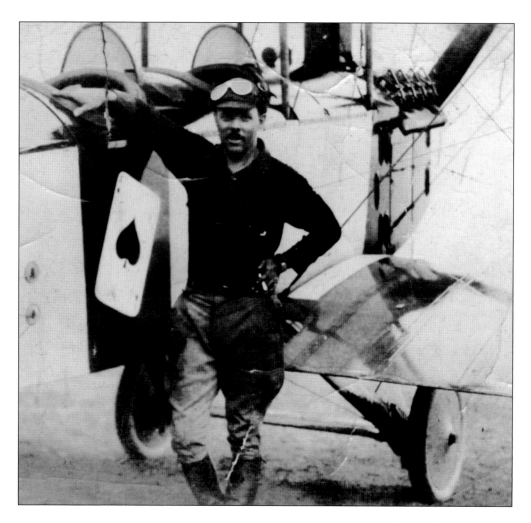

In the years after World War I numerous individuals became involved with aviation, as many commercial operations started up using surplus Curtiss JH-4 (Jenny) aircraft that had entered the civilian market. John Winter (above), a sales agent for Ace Airways, was just one example. A columnist for the *Houston Press*, he was also an avid duck hunter and guide. With thousands of Jennies available as surplus, a flyable one could be purchased for as little as $300; a replacement engine for less than $100. Their low cost opened the skies to entrepreneurial aviators and served as a precursor to the American commercial airline industry. (Both, Story Sloane's Gallery.)

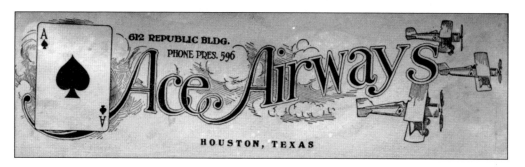

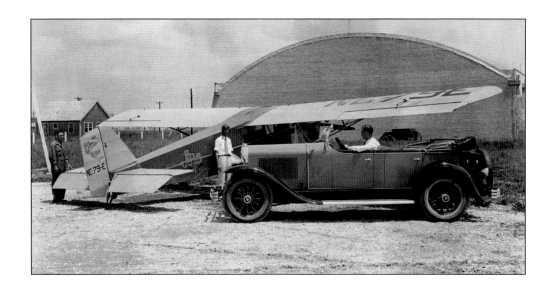

Texas Air Transport (TAT—not to be confused with Transcontinental Air Transport) was founded in 1927 by Temple Bowen, the future founder of Bowen Air Lines. Southern Air Transport acquired it within a couple of years of TAT's creation; Southern also acquired the airmail contracts TAT had obtained across southeast Texas. The route map below shows the various divisions of its future parent, Southern Air Transport, and how the corporate network handled its traffic with Division No. 3, the Texas Flying Service, responsible for passenger traffic. By 1930, Southern, including TAT, became part of American Airways, one of the Big Four corporations of commercial aviation in the 1930s. The others were Eastern, TWA, and United. The Curtiss Robin cabin (pictured above) allowed two passengers to sit together behind the pilot, and with over 700 Robins built, it was a successful airframe for the manufacturer. (Above, Story Sloane's Gallery; below, R.E.G. Davies via Michael Bludworth.)

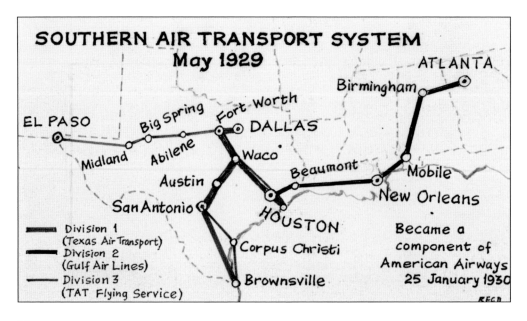

W.L. Edwards was an aviation entrepreneur said to have served with an aero squadron at San Antonio during the Great War. Afterwards, he purchased a Stinson and contracted with the Gulf Production Company, flying to Louisiana and doing aerial photography work. Originally operating out of the Bellaire airfield, he leased 200 acres and transferred his operation to what became known as Edwards Airport, later renamed the Main Street Airport, successfully developing the new airfield. His customers included the Curtiss-Wright Flying Service, the largest business at the airport. (Story Sloane's Gallery.)

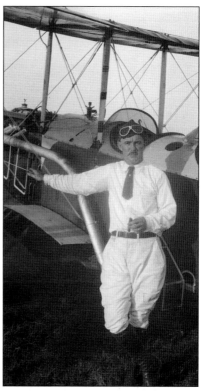

Edwards was the archetype of the 1920s aviator. Seen as courageous, adventurous, and independent, aviators were looked up to as modern heroes, the 20th-century counterpart to knights of legend. With boots, helmets, and goggles, they had a certain élan and distinctive style. One of Edwards's "mounts" was Houston Aerial Transport's Stinson Detroiter, the monoplane version originally developed with six seats for passenger service. Equipped with a heated cabin and electric starter, later versions reached eight seats with Pratt & Whitney engines that had double the horsepower of the original Wright Whirlwind motors. (Story Sloane's Gallery.)

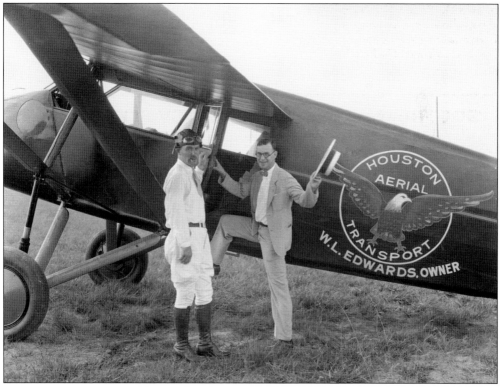

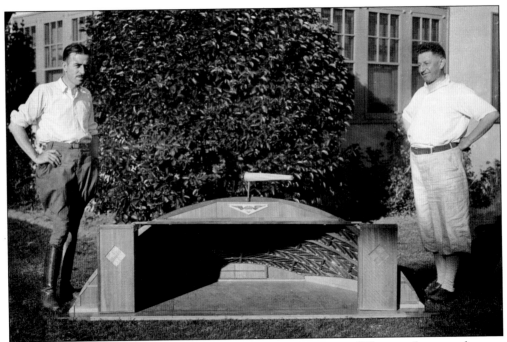

Though having contracted with the No-Truss Hangar Company of Houston for a new hangar, Edwards had lost his airport, including the recently constructed hangar, to foreclosure by 1929. Within the year, he would also lose his life. On May 19, 1930, the *Houston Chronicle* reported the murder of Edwards with the headline " 'Imported Gunmen' Hunted for Killing Houston Aviator." After he had been shot in the head with a sawed–off shotgun, Edwards's body had been dumped east of the River Oaks Country Club. The auto Edwards had been "taken for a murder ride" in was later found partially burned. Within the year, one of the businessmen involved in the foreclosure of Edwards's airport was indicted and tried for hiring a couple of triggermen, who were supposedly attempting to obtain some "papers" but who had killed Edwards when he reputedly reached for a borrowed revolver. (Both, Story Sloane's Gallery.)

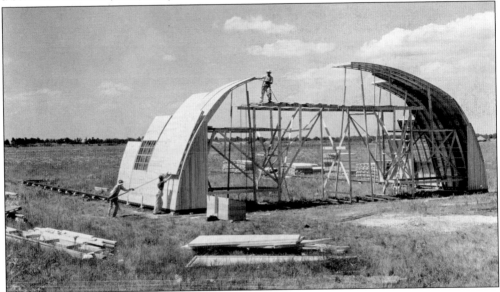

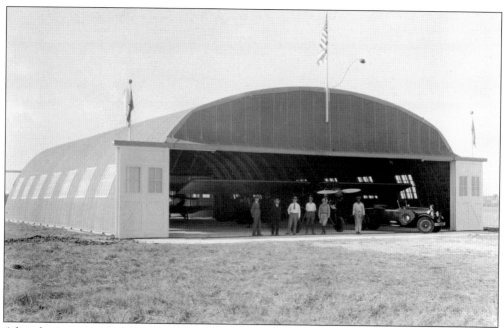

After the jury returned a not guilty verdict against the suspected murderer, one co-conspirator who had testified against the suspect after being granted immunity by the state was himself murdered within the year. In an earlier incident assumed to be related, eight days prior to W.L. Edwards's homicide, federal Prohibition agents had arrested Edwards after supposedly finding liquor in an automobile registered to him. Edwards, claiming that he was framed, stated that the auto's registration had been filed in his name without his knowledge, and he immediately filed a malicious prosecution charge against one individual involved in the transfer, offering a reward in an attempt to locate the suspect. Eventually, one of the Prohibition agents was indicted and convicted for setting Edwards up, receiving a two-year sentence. (Both, Story Sloane's Gallery.)

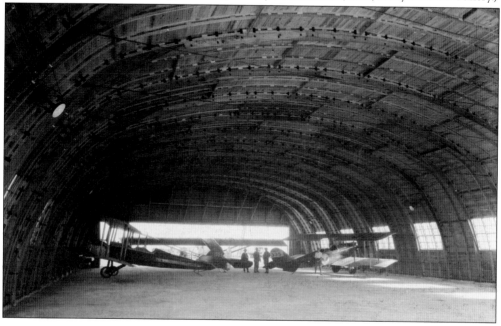

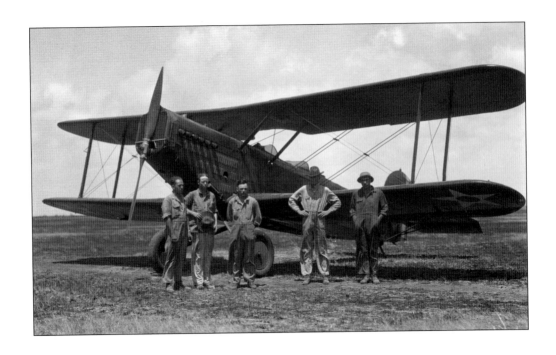

The National Guard conducted summer training and maneuvers at Camp Palacios, southeast of Houston, in the mid-1920s. Originally used by the 36th Infantry Division of the Texas National Guard, the camp, renamed Camp Hulen, had almost 2,000 concrete tent floors installed by 1934. Eventually developed as an antiaircraft training site, 400 buildings along with 2,800 tents were in place during World War II. Palacios Army Airfield was also constructed during the war, later becoming the Palacios Municipal Airport. The Douglas O-2H aircraft, mounted with a 435-horsepower Liberty engine, was first built in 1928, four years after the initial O-2s were constructed. It was designed originally with two cockpits; one model had three cockpits, allowing up to four passengers. The success of these and other aircraft was due, in no small part, to the work of the mechanics who maintained them. (Both, Story Sloane's Gallery.)

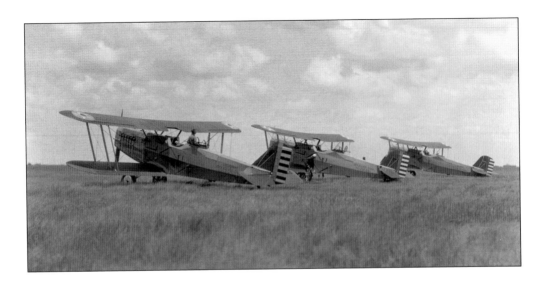

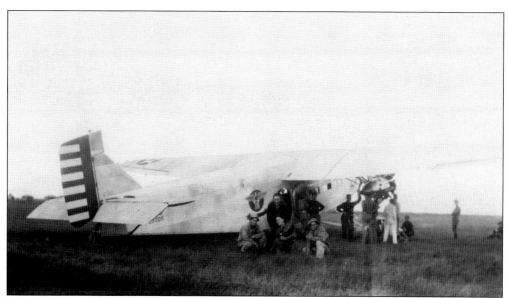

The Army Air Corps used Ford Trimotors as transports and hacks, allowing a flight squadron to transport the supplies and personnel needed to maintain a squadron's primary aircraft. Above, 29-226, one of seven 4-AT-E models, operated with Wright R-975-1 radial engines of 300 horsepower each and was designated C-9 by the Army, with other versions labeled as C-3, C-3A, C-4, and C-4A, the type number primarily dependent on the engine in use. The US Army tail striping of alternating red and white was used between 1926 and 1942. Of all-metal construction, the siding of the Trimotor was of corrugated aluminum. The Douglas C-1, shown below, was part of the continuing development of medical transportation in the interwar years. Powered by a Liberty engine, with its enclosed passenger compartment, it was modified to transport four litters along with attending medical cadre. (Both, Michael Bludworth.)

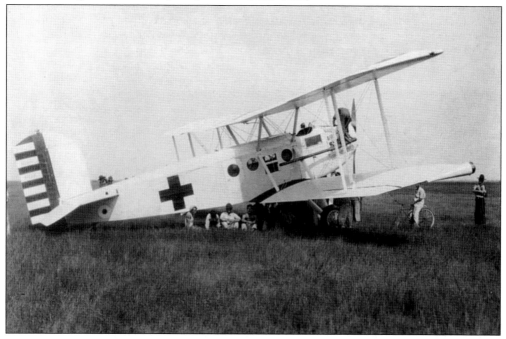

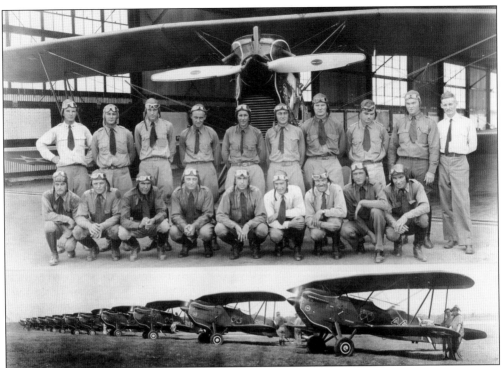

The 3rd Attack Group, based out of Fort Crockett, Galveston, since 1926, operated the Curtiss A-3 in the 1920s. As a ground support aircraft, it had been developed from the Curtiss O-1 to carry bombs and was mounted with dual machine guns. In 1928, the pilots of the 3rd participated in the national races in Los Angeles, competing for the Mason M. Patrick Trophy. In 1929, the pilots competed again at the Cleveland air races. The following year, the last competition for the trophy, limited to the commissioned pilots of the 3rd Attack Group, was held at Fort Crockett. Below, the advanced Curtiss A-8, the first low-wing monoplane to enter standard service, replaced the A-3s in 1932. Powered by a liquid-cooled 600-horsepower engine, the A-8 carried four machine guns with a fifth for the rear gunner along with wing-mounted bomb racks. (Both, Rosenberg Library, Galveston.)

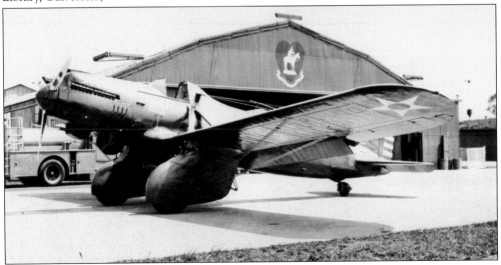

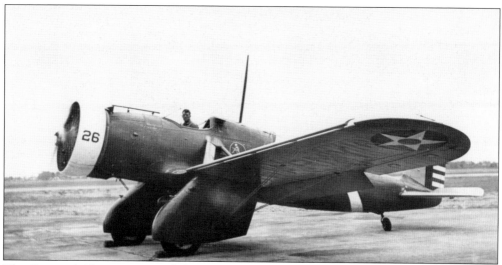

The Curtiss A-12 was an upgraded version of the earlier A-8, mounting an air-cooled Wright R-1820-21 radial engine that developed 690 horsepower. With four .30-calliber machine guns forward and the rear gunner operating a fifth, the A-12 was also, like its predecessor, equipped with bomb racks. On November 5, 1934, Lt. Col. Horace Hickam, the commander of the 3rd Attack Group, was killed while attempting to land an A-12 at Fort Crockett, Galveston. Hickam Field, Hawaii, was named in his honor. The 3rd Attack Group was transferred from Galveston to Barksdale, Louisiana, shortly afterwards. No American A-12 saw combat, though some were on Hickam Field when the Japanese attacked Pearl Harbor. An export version saw service with the Chinese nationalists against the Japanese prior to Pearl Harbor. (Above, Rosenberg Library, Galveston; below, National Museum of the USAF.)

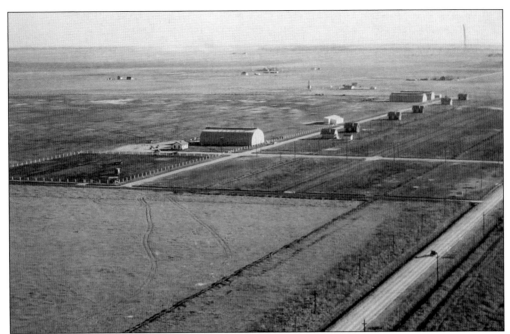

The Houston Airport Corporation, owned by lumberman W.T. Carter Jr., opened a 193-acre airfield on Telephone Road in 1927. By 1928, Contract Air Mail (CAM) Route No. 21 was inaugurated by the bus pioneer Temple Bowen's Texas Air Transport, bringing airmail service from Houston to Galveston and Dallas using Pitcairn Mailwings. Gulf Coast Airways initiated CAM Route No. 29 between Houston and New Orleans the following year with Texas Air Transport and Gulf Coast Airways merging shortly afterwards to form Southern Air Transport. In 1930, Southern was acquired by American Airways. The Pitcairn PA-5 Mailwing, operating with a Wright engine, had an original range in excess of 400 miles, with later versions exceeding 500 miles. Recognized as an efficient transport aircraft, over 100 were manufactured in various models from 1927 to 1930. (Above, Story Sloane's Gallery; below, Rosenberg Library, Galveston.)

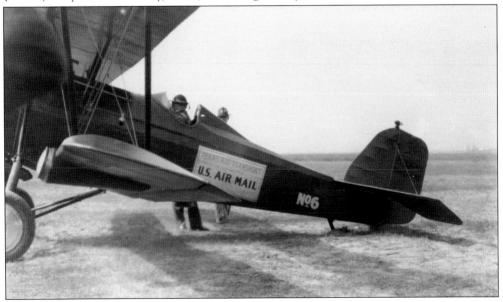

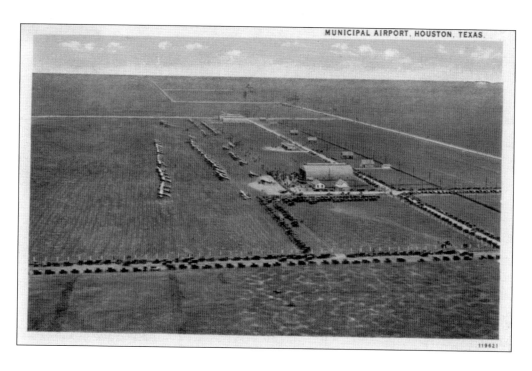

Besides serving as Houston's municipal airfield, it also hosted the 111th Observation Squadron, a Texas National Guard unit stationed previously at Ellington Field. With its headquarters having relocated to donated office space in the Gas Company Building in downtown Houston, its aircraft operated out of the southwestern area of the Houston Municipal Airport for over a decade. Besides occupying two steel hangars (similar to the one located at the north end pictured below), five cottages were also available for the unit's full-time mechanics and their families. The 111th, known as "Houston's Own" and nicknamed the "Ace-in-the-Hole" Squadron, had been formed in 1923. Originally operating Curtiss Jennies and De Havilland DH-4s, the unit eventually transitioned to Douglas O-2Hs followed by Douglas O-38s. (Both, Michael Bludworth.)

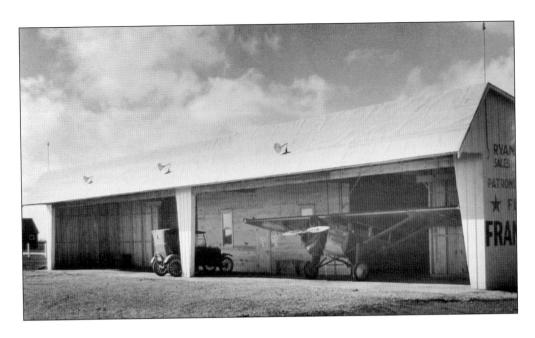

Lt. Frank Hawks was one of the first tenants on the new airfield, operating a Ryan Aircraft dealership for many years. Learning to fly in Long Beach before the Great War, Hawks served as an instructor in Texas during the conflict. Afterwards, he traveled on the barnstorming circuit for a time. Hired by Texaco to market aviation related products, Hawks used a variety of aircraft and his own personal fame to market the Texaco brand. In 1929, ferrying a Lockheed Air Express, Hawks set a new transcontinental speed record flying from California to New York in 18 hours and 22 minutes. The fuel supplied on the airfield was from Sinclair Oil. Harry Sinclair had built a refinery on the Houston Ship Channel in 1920, allowing Sinclair to process local crude oil for shipment to the East Coast market. (Both, Michael Bludworth.)

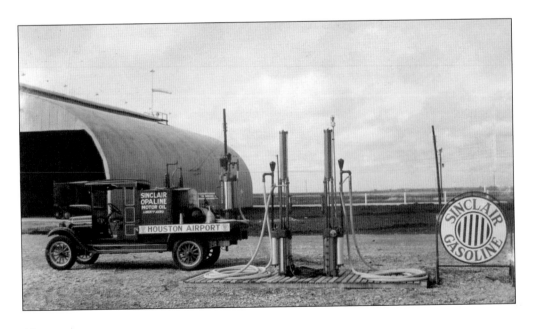

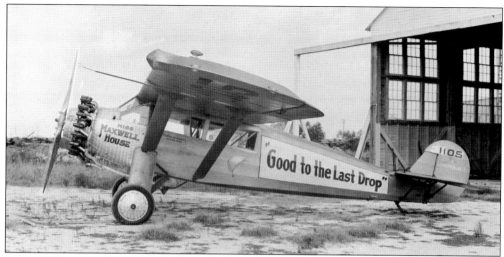

Maxwell House coffee also utilized aircraft, in this case a Ryan B-1, for advertising purposes. The Ryan B-1, similar in looks to the one-off NYP model built for Charles Lindbergh's solo Atlantic crossing, had a successful run, with 150 constructed in the following years. Frank Hawks, obtaining the sponsorship of Maxwell House—who operated a coffee roasting facility in Houston—entered the *Miss Maxwell House* in the Air Transport Speed and Efficiency Trophy Race in 1927. The original registration number of NC3009 can be partially viewed under the then-current number of 1105. The composite photograph below is an early example of photo manipulation for advertising. The airplane had been photographed on the ground with the background masked out and the skyline shot separately. Camera shutter speeds at the time were not fast enough to make a propeller in motion appear to stand still. (Both, Story Sloane's Gallery.)

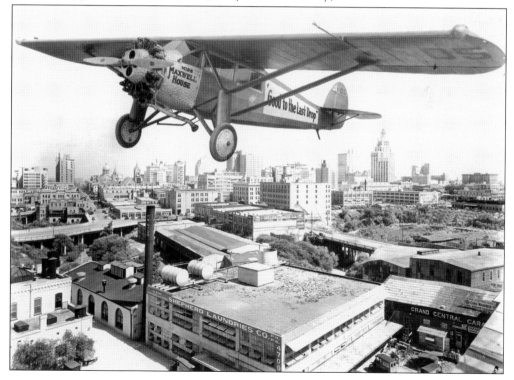

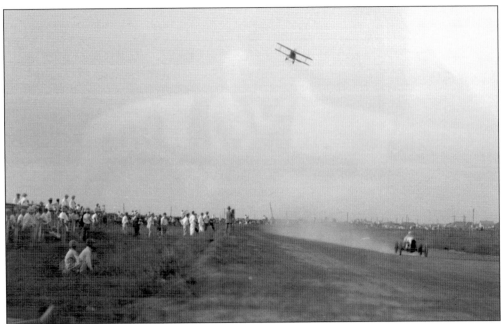

Throughout the 1920s, exhibitions of speed and daring offered the public an opportunity to vicariously live the life of excitement and glamour. As aircraft technology developed, manufacturers turned to various forms of competition to substantiate their claims of safety—critical to the public's acceptance of aviation as something other than a niche endeavor suited to the adventurous. Endurance flights proved the reliability of airframes and engines, and competition winners were honored financially and in the media. A Houston endurance plane, the *Billion Dollar City*, flew over 233 hours before the engine seized on the Stinson Detroiter shortly after its 26th mid-air refueling. Three days later, Dale Jackson and Forest O'Brine completed their own endurance flight in the *St. Louis Robin*, setting a new record of 17.5 days. On the previous day, a third endurance plane had crashed in Minnesota, killing the pilot. (Both, Story Sloane's Gallery.)

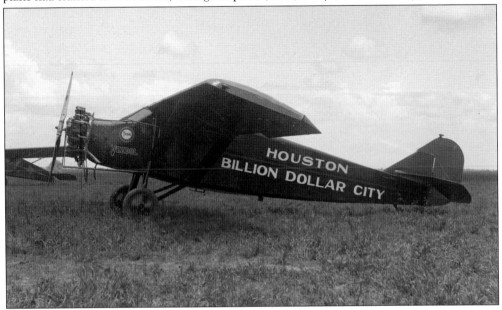

Three

THE 1930S

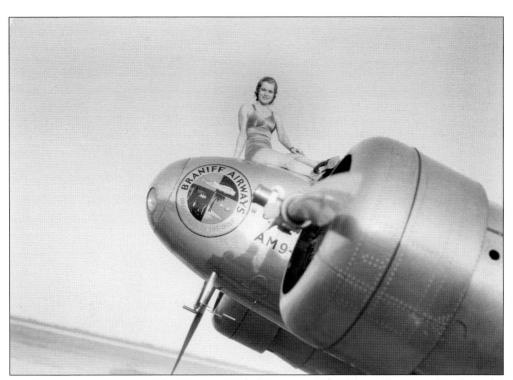

The Braniff Airways logo of the 1930s reminded customers of its range of operations—from the Great Lakes to the Gulf—but also from urban communities such as Chicago to the beach resorts of Galveston. The logo also accented the carrier's use of the twin-engine Lockheed 10 Electras. The model sitting on top reinforced the Gulf Coast's resort persona. (Briscoe Center for American History, University of Texas.)

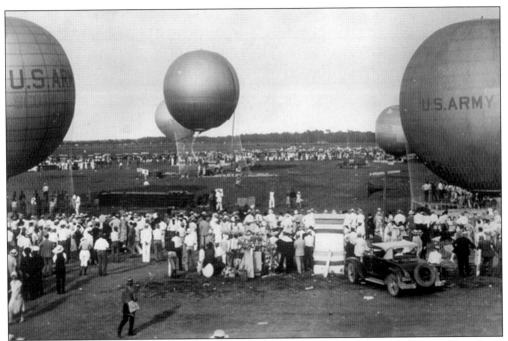

In 1930, the National Elimination Balloon Race was held in Houston. An annual lighter-than-air event, it was used to determine the American entrants to compete for the Gordon Bennett Cup, an international distance ballooning competition. Fifteen entrants launched on the Fourth of July. Due to the prevailing air currents, the crews traveled northeast upon launching, with the best winds being found between 850 and 1,200 feet. Radio station KTRH installed a radio transmitter in an airplane and followed the launch for some miles before returning to Houston. Thunderstorms eventually grounded many of the bags in the Texarkana area. Of the five that continued, Roland Blair and Frank Trotter, manning a Goodyear-Zeppelin balloon, drifted 850 miles into Kentucky to claim the win and a place in the year's Gordon Bennett race. (Both, Story Sloane's Gallery.)

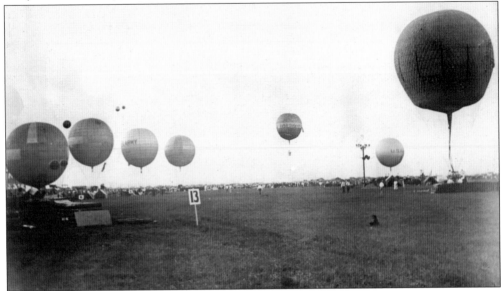

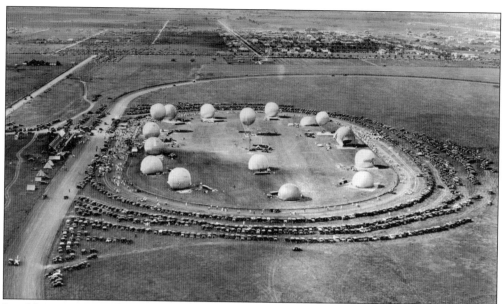

In addition to privately funded balloons, numerous Army and Navy balloons, with one Army balloon representing the City of Houston, participated. United Van Service, Aero Digest, the *Detroit News*, General Electric, and Kelvinator were among the corporate sponsors. The 15 balloons were launched from Bellaire Speedway, earlier known as Houston Speedway, the scene of numerous flying and auto racing exhibitions over the years. Clarence Chamberlin, an early airline entrepreneur who utilized a fleet of modified Condors to travel the barnstorming circuit, operated the Curtiss Condor 18, shown below. By stripping out the interiors to add extra seating, Chamberlin offered sightseeing rides to almost two dozen paying passengers per flight versus only taking one or two people aloft on each hop as was done in the earlier Jennies, for example. On the ground in the center of the group is a Texaco star logo. (Above, Story Sloane's Gallery; below, Briscoe Center for American History, University of Texas.)

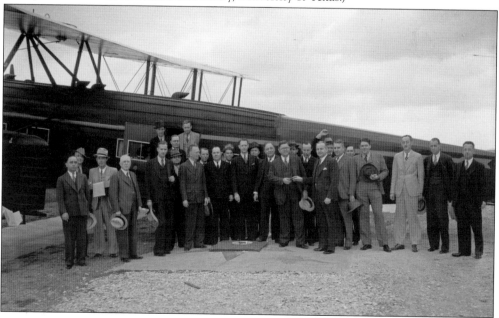

Throughout the 1930s aviation continued to be glorified, with records constantly being challenged and broken and technology being expanded beyond what many thought possible a generation earlier. Air shows continued to attract many, and aircraft such as the Gee Bee Sportster and the Great Lakes 2T were found in attendance. The five Granville brothers built two legendary racers, the R-1 and R-2, with Jimmy Doolittle winning the Thompson Trophy in one in 1932. The Model E Sportster shown above had a Warner Scarab radial engine. The venerable Great Lakes biplane, shown below, is still being produced today and continues to perform in air shows as well as function as a trainer to introduce fledgling pilots to handling unusual attitudes such as inverted flight and dealing with stalls and spins. The aircraft behind the Great Lakes is a Bird CK. (Above, MSS0253-049, Houston Public Library, HMRC; below, MSS0253-050, Houston Public Library, HMRC.)

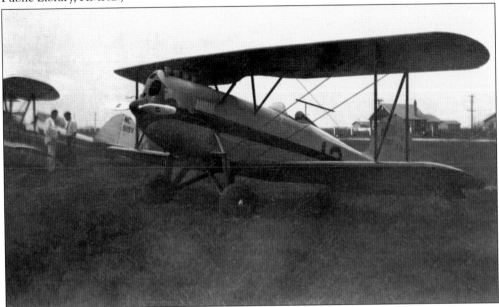

The development of aviation and the advance of cinematography in the early years of the 20th century led to a symbiotic relationship between the two fields. The glamour associated with aviation in the early 20th century led Hollywood to make numerous action films in the early years, while the success of films in popular culture extended the allure and fascination of aviation beyond the local aerodromes. In 1929, the first-ever Best Picture Oscar was awarded to *Wings*, a silent war film set in World War I; a year later, Howard Hughes's *Hell's Angels*, also set in the Great War, was released. *West Point of the Air*, being promoted with a pseudo-aviator at right, was released in 1935 during the run-up to World War II. Aviation was also used to promote local businesses such as Raymond Pearson, a major Ford dealer in Houston, whose name is advertised on the side of a Travel Air below. (Right, Briscoe Center for American History, University of Texas; below, Story Sloane's Gallery.)

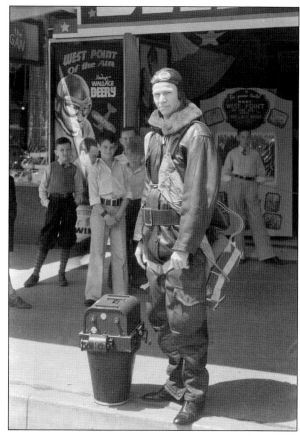

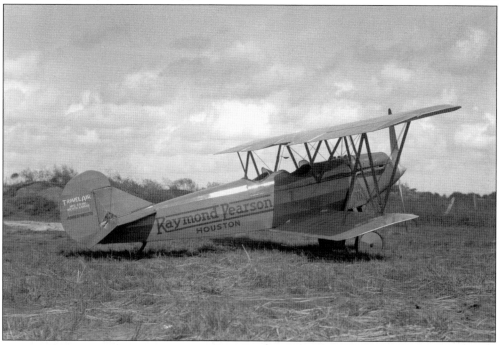

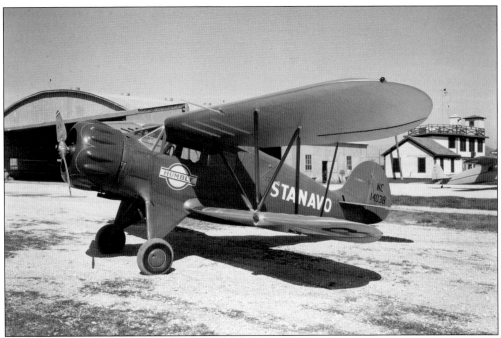

The Stanavo Specification Company was a subsidiary of the Standard Oil companies of New Jersey, Indiana, and California. Because of a Texan animosity to the Standard Oil trust, it became advantageous for Standard to operate in Texas through its affiliate, the Humble Oil and Refining Company, 50 percent of which was owned by Standard of New Jersey in 1919 and 72 percent by 1948. Stanavo became the international brand for the company's aviation gasoline and oil. The Waco CJC pictured above was one of a fleet of over 30 various aircraft operated by Standard Oil of New Jersey and its affiliates in the 20 years before World War II. Humble operated at least three aircraft, including two twin-engine Lockheed 12A Electra Juniors (below), besides the Waco. (Both, Story Sloane's Gallery.)

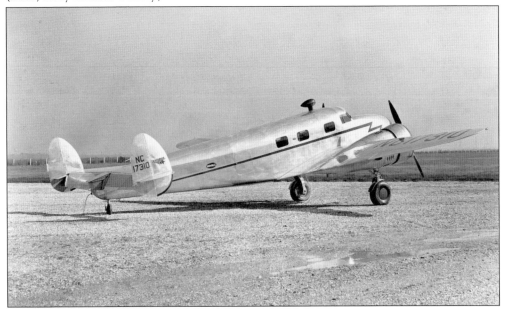

FRANK HAWKS

AMERICAN PILOT - WHO DRAMATIZED THE USE OF SPEED FOR AIRPLANE TRAVEL. HIS RECORD FLIGHTS ARE NOW THE COMMONPLACE ROUTINE OF THE SCHEDULED AIR LINES. HE LEARNED TO FLY AT LONG BEACH, CALIFORNIA, BEFORE THE WAR. HE INSTRUCTED CADETS DURING THE WAR AND THEN "BARNSTORMED" IN THE U.S. AND MEXICO AFTER ITS CLOSE. HE LATER MADE MANY LONG-DISTANCE SPEED FLIGHTS, BOTH IN AMERICA AND EUROPE.

HALL OF FAME OF THE AIR

BY CAPT. EDDIE RICKENBACKER
DRAWN BY CLAYTON KNIGHT

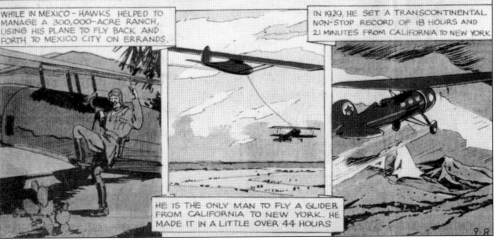

WHILE IN MEXICO - HAWKS HELPED TO MANAGE A 300,000-ACRE RANCH, USING HIS PLANE TO FLY BACK AND FORTH TO MEXICO CITY ON ERRANDS.

IN 1929, HE SET A TRANSCONTINENTAL NON-STOP RECORD OF 18 HOURS AND 21 MINUTES FROM CALIFORNIA TO NEW YORK

HE IS THE ONLY MAN TO FLY A GLIDER FROM CALIFORNIA TO NEW YORK. HE MADE IT IN A LITTLE OVER 44 HOURS

As early as the 1920s, the Texas Oil Company recognized the advantages of utilizing Frank Hawks to market its refinery products to the developing aviation industry, hiring Hawks as the director of its aviation department in 1932. Hawks's record-setting prominence offered Texaco an admired face behind the Texaco star. (Michael Bludworth.)

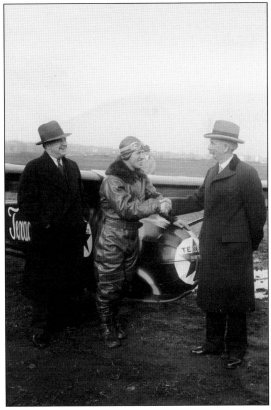

In continuing to market its brand to aviators, Texaco recognized the future advantages of highlighting its name in the glider community, realizing that many would continue on to powered flight. Texaco and Hawks developed an exhibition of long-distance gliding by having a Franklin glider, known as the *Eaglet* (and later as the *Texaco Eaglet*) towed across the United States by a Waco Ten tow plane, with glider demonstrations at every landing site. Departing March 30, 1930, from San Diego, they completed their 2,860-mile flight to New York City on April 6. (Library of Congress.)

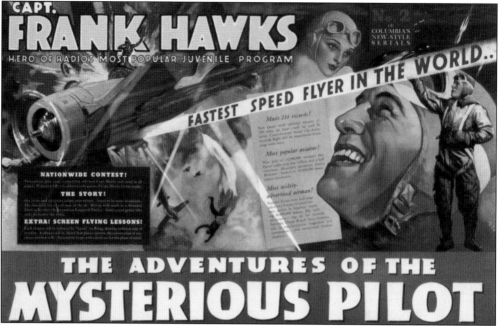

In 1930, Texaco bought one of the five "Mystery Ships" built by the Travel Air Manufacturing Company for Hawks to compete in the National Air Races. Though unsuccessful at Cleveland, Hawks set a transcontinental speed record as well as numerous long distance records in the early 1930s. Hawks and his Mystery Ship, marked as *Texaco 13*, inspired a 1937 Columbia Pictures serial starring Hawks titled *The Adventures of the Mysterious Pilot*; one of the writers collaborating on the series was L. Ron Hubbard. In promoting Texaco products, Hawks went on to operate a Northrop Gamma 2A, branded as the *Texaco Sky Chief*, a name later used by Texaco to market its premium grade of gasoline. Hawks died in 1938 while promoting a Gwinn Aircar, killing himself and his prospective customer. (Above, Michael Bludworth; below, Boston Library.)

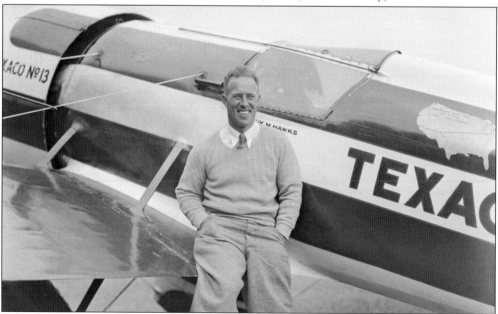

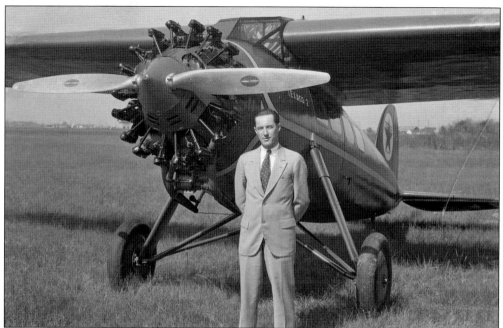

The Texas Oil Company, later known as Texaco, originally developed after the oil boom at Spindletop, Texas, quickly expanding nationally with refineries and pipelines across the West as well as in Europe. Marketing nationally, Texaco swiftly took advantage of the economic advantages of aviation while pursuing the commercial aviation market. The Lockheed Vega *Texaco 2* provided transportation to Burt E. Hull, the president of the Texas Pipe Line Co. The Vega, designed by John Northrop and Gerald Vultee, became a record-setting airframe with one being used by Amelia Earhart and another, the *Winnie Mae*, being piloted by Wiley Post on the first round-the-world solo flight. After crashing in Houston in 1930, the *Texaco 2* was rebuilt and sold the following year. The Keystone-Loening amphibian, *Texaco 23*, was operated by the Louisiana-Arkansas Production Department. The landing gear wheels swung up under the wing when operated on water. (Both, Briscoe Center for American History, University of Texas.)

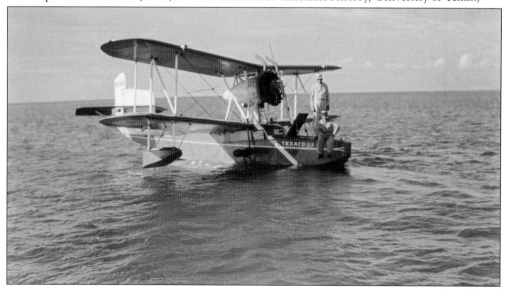

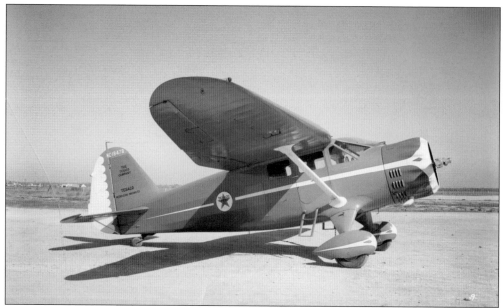

The Stinson SR10E *Texaco 29* was obtained in 1938 for sales usage. Retained until after the war, she was powered by a 320-horsepower Wright engine. The Stinson was one of at least six SRs with various engine configurations acquired in the mid-1930s along with two earlier models of the Stinson SM. During the war, some Stinson Reliants were impressed into service, with production continuing for shipment to the Royal Navy as the AT-19. *Texaco 35*, a Howard DGA-15W mounting a 350-horsepower Wright, was also a sales asset. The DGA (for Damn Good Airplane) was first built in 1933, and versions continued in production during the war in various configurations including as a transport, trainer, and ambulance. With a variety of engines over the years in the Howard, one version, a DGA-6 known as *Mister Mulligan*, was a major air race success in 1935, winning the Bendix Trophy and the Thompson Trophy. Texaco acquired 29 in 1940. (Both, Briscoe Center for American History, University of Texas.)

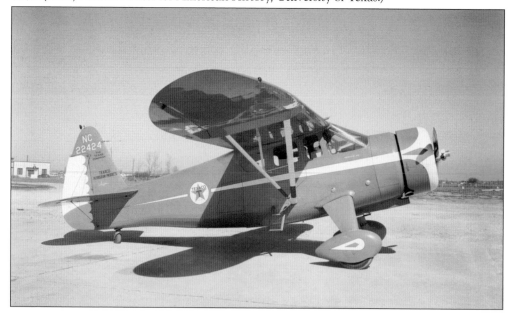

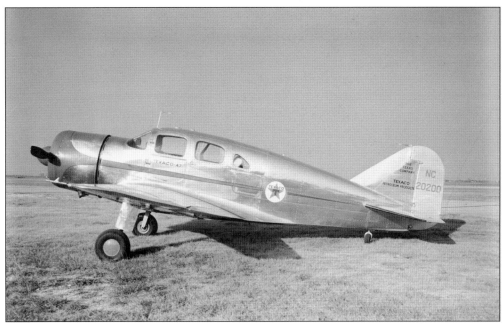

Texaco 47, a Spartan 7W Executive, was utilized by sales in fulfilling its marketing requirements. Developed as an executive transport by the original owner of Spartan, William Skelly of Skelly Oil, and introduced in 1936 when Spartan was under the corporate control of J. Paul Getty of Getty Oil, Texaco eventually operated at least four Executives, having also previously utilized a Spartan C3-225 biplane, all used by sales except for one Executive in the pipeline department. With a 450-horsepower Pratt & Whitney Wasp Junior engine, a 7W cruised at 200 miles per hour while having an operating range of 2,000 miles. Only 34 Executives were produced. Texaco purchased its first Executive in 1940, with *Texaco 47* being purchased in 1945. The photograph below shows the three Texaco aircraft together at Houston. (Both, Briscoe Center for American History, University of Texas.)

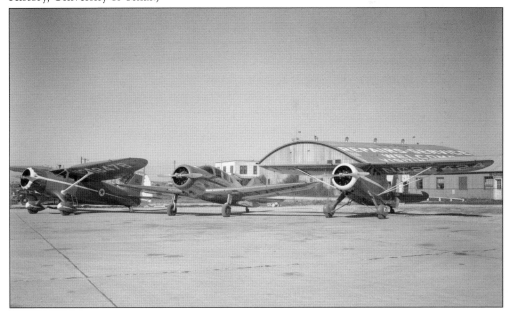

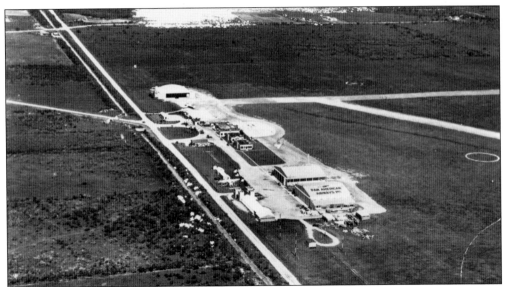

Houston's aviation development would be in a symbiotic relationship with the cities of Dallas, New Orleans, San Antonio, and Brownsville in the 1930s. In 1929, Pan American Airways received the contract for the Foreign Air Mail Route (FAM-8) from Brownsville, Texas, to Mexico City, effectively subsidizing passenger traffic from the United States. TAT from San Antonio provided domestic air shuttles to Brownsville; Houston passengers had the option of traveling by train to Brownsville before boarding the flight to Mexico City. Domestic air service by Braniff, and later Eastern (*The Mexico Flyer*), eventually followed. Brownsville Airport was dedicated in 1929 with Pan American developing extensive terminal and maintenance facilities at the airfield to serve its passengers and air fleet for the next 30 years. The opening ceremonies included Charles Lindbergh's arrival from Mexico City with the first airmail transported over the new route. Amelia Earhart was present; shortly afterwards, she earned her commercial transport license there. (Both, University of Miami)

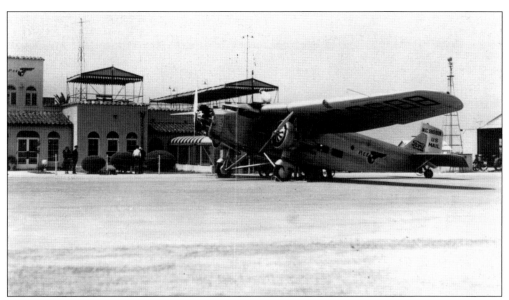

Lindbergh's original five-and-a-half-hour flight from Mexico City was flown in a Ford Trimotor, similar to the one pictured above. The backbone of Pan American's empire throughout Latin America, almost 200 were built by the Stout Metal Airplane Company under Henry Ford's ownership. One version, the 4-AT (Air Transport) came equipped with 220- or 300-horsepower Wright Whirlwinds, while the 5-AT used 420- or 450-horsepower Pratt & Whitney Wasps, a more suitable power plant for South American operations. Another airframe developed in the 1920s and powered by the Wasp engine was the Fokker Super Universal, one of which was purchased by Goodyear in 1929 for tire testing. The Universal was an American design, built by the American subsidiary of Fokker. Its then manager Robert Noorduyn was later known for his design and development of the Noorduyn Norseman. Goodyear flew NC9792, shown below, until 1933, when it ended up in Alaska as part of the inventory of Northern Air Transport. (Above, University of Miami; below, Michael Bludworth.)

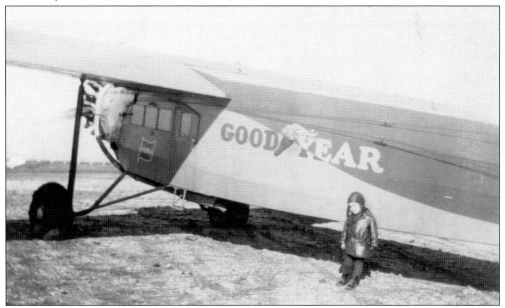

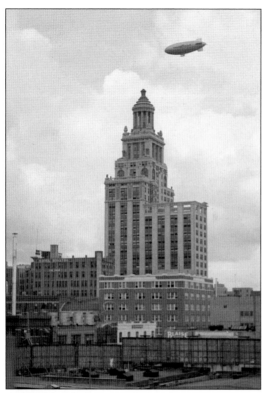

Goodyear Tire and Rubber Company established the Goodyear-Zeppelin Corporation to develop airships in the United States. In a marketing move, a blimp was commissioned in 1925 to advertise the logo of Goodyear nationwide. Four more followed over the next few years. In 1927, Goodyear also worked with the Army and Navy to construct several balloons for military use, some of which competed in the 1931 National Elimination Balloon race in Houston. One of their airships is shown above the Niels Esperson Building in downtown Houston. (Story Sloane's Gallery.)

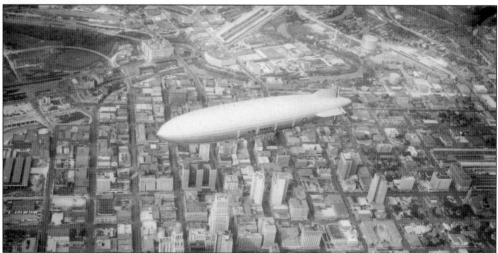

In 1928, Goodyear-Zeppelin started the process of developing the infrastructure required to build the rigid framed airship USS *Akron* (ZRS-4). After two years of construction, the *Akron* was launched in 1931. Almost 800 feet long, it was capable of carrying 90 crewmembers and passengers while cruising at 60 miles per hour; her potential range was almost 7,000 miles. Her size allowed the *Akron* and her sister ship the USS *Macon* to internally carry small single or two-seater aircraft, launching and recovering them from a lowered "skyhook" or "trapeze" device. In 1932, the *Akron* passed over Houston on its three-day cross-country journey to California. Within the year she would be lost, along with 73 of her 76 passengers and crew, in a storm off the New Jersey coast. (Texas National Guard.)

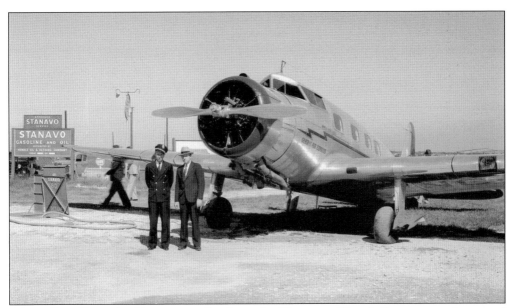

After selling Texas Air Transport to Southern Air Transport, Temple Bowen started a second airline using Lockheed Vegas. Originally operating between Houston, Dallas, and Fort Worth, Bowen Air Lines carried over 12,000 passengers in its first year, yet by 1935, the airline consolidated with Braniff Airways. The Vultee V-1 shown above carries the General Air Express markings of a freight operation conducted in partnership with other airlines competing against the Railway Express Agency freight system. Grand Prize beer became the most popular beer in Texas, brewed locally by Howard Hughes's Gulf Brewing Company. Operating for 30 years, it was eventually bought out by the Theodore Hamm Brewing Company in 1963 as part of an expansion plan to allow Hamm's to be brewed and marketed nationally. The NRA sticker on the Vega refers to the National Recovery Administration, a "New Deal" agency of the 1930s. (Both, Story Sloane's Gallery.)

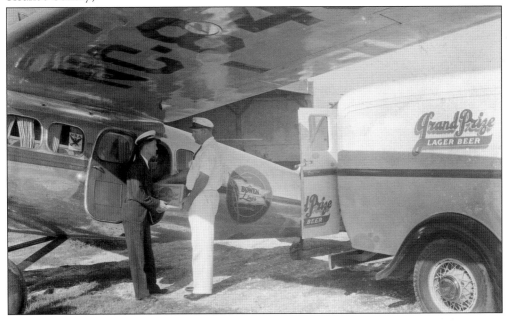

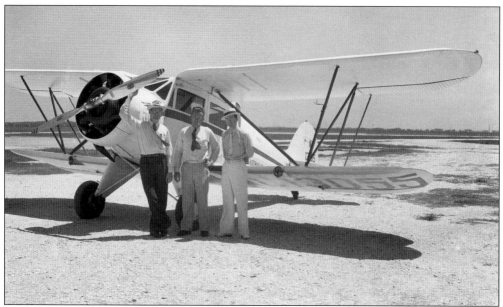

Oil field service companies, including Eastman Oilwell Survey, recognized the multiple benefits of corporate aircraft. This Waco UEC, one of 40 eventually built, operated with a 210-horsepower Continental engine. Covered with fabric, the various models carried four to five persons. Developed from the Waco F-2 biplane, it maintained the biplane's short field capabilities. Frank and William Robertson, after a venture manufacturing the Curtiss Robin, started the Robertson Airplane Service Company using Ryan B-5 Broughams, two of which are shown below at the Houston Municipal Airport. The Broughams offered seating for six thanks to a 300-horsepower Wright Whirlwind engine powering the aircraft. Providing mail, passenger, and freight service between New Orleans and Houston, its route would be taken over by Wedell-Williams Air Service, which shortly afterwards merged with Eastern in 1937. (Above, Story Sloane's Gallery; below, Briscoe Center for American History, University of Texas.)

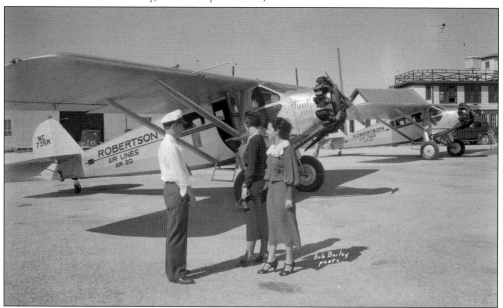

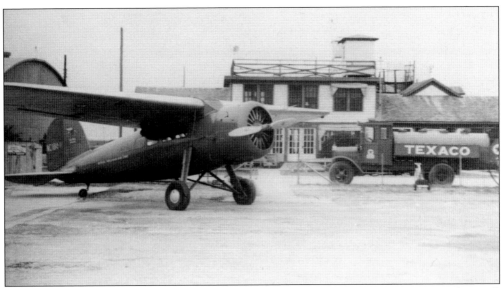

The Wedell-Williams Air Service was founded in 1929 by Jimmy Wedell, an air racer and aircraft designer, and Harry P. Williams, a successful businessman involved in lumber, oil, banking, and sugar plantations in Louisiana. Born in Texas City in 1900, Wedell had the opportunity to see the Army's 1st Aero Squadron in operation prior to World War I. Winning the Thompson Trophy in 1933, Wedell also captured the world land-speed record, both feats accomplished in an aircraft of his own design, the Wedell-Williams 44. Wedell died in a flying accident in 1934; Williams was killed in an aircraft crash in 1936. Eastern Air Lines purchased Wedell-Williams in December 1936, including its airmail route from New Orleans to Houston. An accidental fire destroyed the Houston Municipal Airport terminal, pictured behind the Wedell-Williams Vega above, shortly after the opening of the new Art Deco terminal in 1940. (Both, Briscoe Center for American History, University of Texas.)

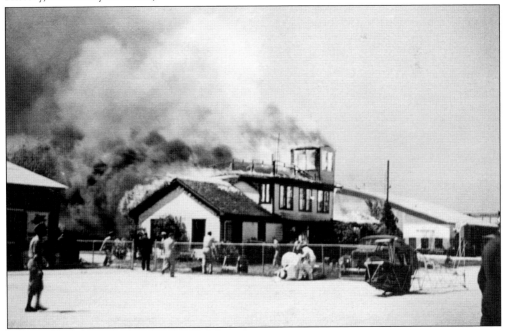

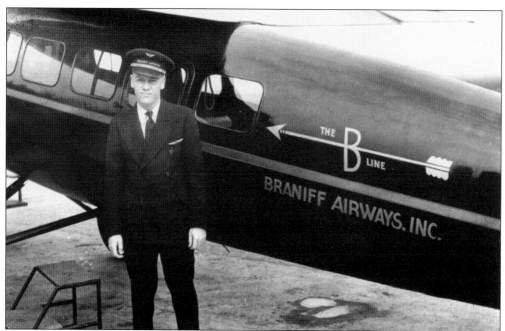

In 1935, Braniff Airways, created five years earlier by its namesake Tom Braniff, purchased the Long & Harman Airlines and in the process acquired its Texas airmail contract. Within the year, Braniff had extended its routes into Houston. R.V. Carleton (above), one of their first pilots, was later a vice president of Braniff in the 1960s. Originally operating two Lockheed Vegas, offering speed over capacity, Braniff eventually purchased Lockheed 10A Electras. Five were part of a fleet of 17 aircraft in mid-1935. The all-medal L-10s offered the safety of twin engines, generally 450-horsepower Pratt & Whitney Wasp Juniors, along with increased speed and carrying capacity. Amelia Earhart was flying a modified Electra when she disappeared over the Pacific in 1937 while attempting her round-the-world flight. NC14905 crashed at Love Field two days before Christmas of 1936. (Above, MSS0157-0064, Houston Public Library, HMRC; below, Briscoe Center for American History, University of Texas.)

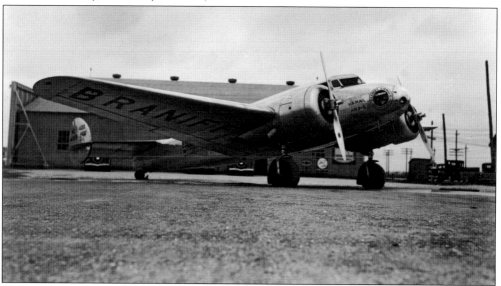

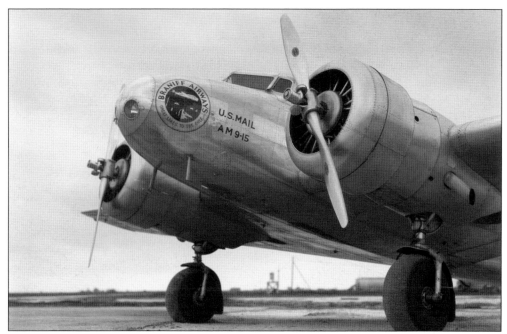

The US Mail AM 9-15 markings on the nose of this Braniff Electra identifies the original funding source, the US Post Office, that subsidized the development of American commercial aviation, achieved in spite of a worldwide economic depression. In 1925, Congress passed the Kelley Act, "an Act to encourage commercial aviation," that directed the postmaster general to establish contracts with commercial air carriers to transport mail by aircraft across specified routes. These contracts provided a guaranteed source of revenue for the fledgling airlines, funding their infrastructure and allowing them the time to develop a consistent passenger base. The original routes were identified as Contract Air Mail (CAM) routes, with Houston and Galveston serviced by Bowen's Texas Air Transport (TAT) CAM No. 21 starting in 1928. After the 1934 Air Mail Scandal, the contracting system was reorganized, with Braniff awarded Air Mail (AM) Route No. 9. After buying Long and Harmon Airlines, Braniff also acquired AM Route No. 15 serving Houston and Galveston. (Above, Briscoe Center for American History, University of Texas; below, R.E.G. Davies, courtesy of Michael Bludworth.)

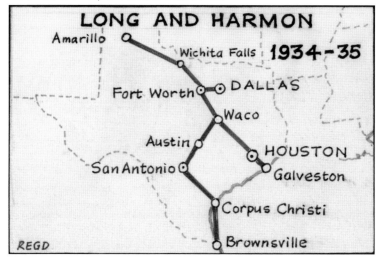

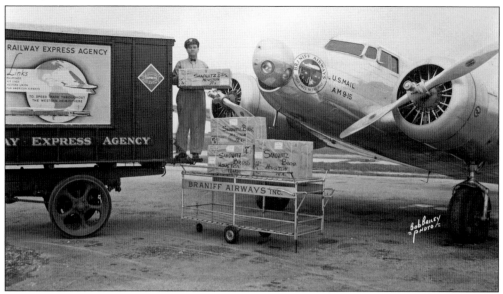

The Railway Express Agency was a parcel shipment confederacy jointly owned by the nation's railroad companies. Originally established during World War I as part of the federalization of the nation's train system, the major express companies of the time—Adams Express and its subsidiaries Southern Express, American Express, and Wells Fargo—were merged into the American Railway Express Company, then bought out by the railways in 1929. Holding a monopoly on railroad express service, which was prioritized above the railroads' own freight operations, it was required to handle any and all freight, including, supposedly, even a pair of giraffes. It developed into the largest ground and air express service, eventually having agents in 23,000 communities. By 1939, it could deliver a package 2,500 miles overnight. Yet even the most successful business model can have unexpected difficulties, as exemplified by the accident below involving one of its delivery fleet vehicles. (Both, Briscoe Center for American History, University of Texas.)

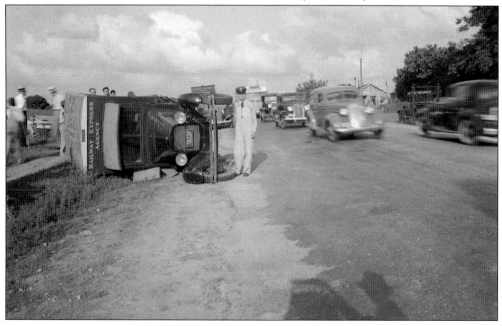

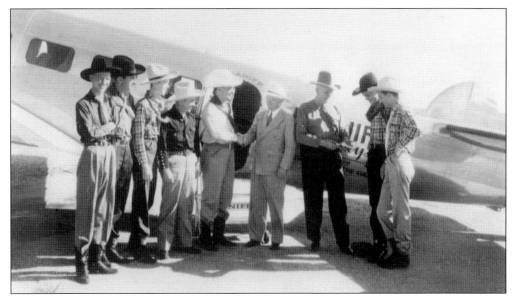

As Braniff Airways expanded, promotional photographs were one way of attracting passenger traffic on its air routes. In a symbiotic relationship with civic promoters, marketing shots were distributed to increase interest, attendance, and passenger numbers. In 1937, the Houston "cowboys" were promoting the Houston Fat Stock Show and Livestock Exposition, today known as the Houston Livestock Show and Rodeo. The first show was held in 1932 at the Democratic Convention Hall; a decade later, Gene Autry was the first star entertainer. As early as 1920, Galveston was hosting the Bathing Girl Revue; one newspaper reported tens of thousands visited Galveston during the Revue. Galveston marketed itself as the "Treasure Island of America," both a port and a "playground," and the photograph of the two fishermen and the model in a bathing suit play off of the island promoters' theme. (Above, 1940 Air Terminal Museum; below, Briscoe Center for American History, University of Texas.)

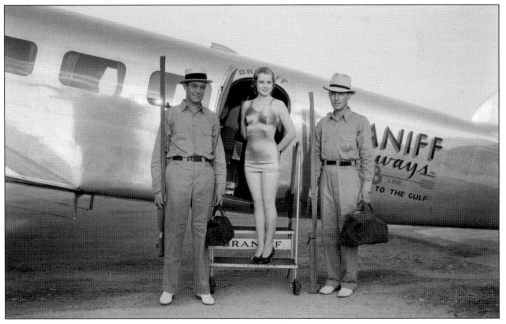

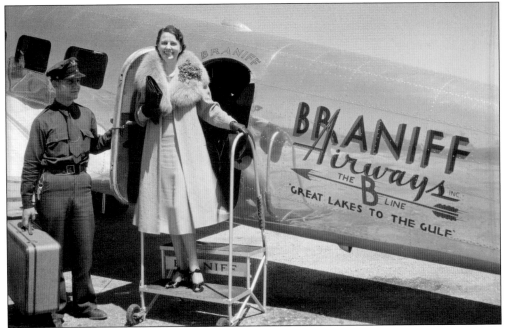

Other Braniff promotion photographs include "Mrs. Hart" at Houston with an attendant carrying her baggage and a group reputedly bound for New York. In the mid-1930s, Braniff's routes extended north to Kansas City and Chicago. Any passenger traveling to New York would have had to change to American Airlines, TWA (Transcontinental & Western Air), or United Airlines; along with Eastern Air Lines, they made up the "Big Four" of commercial aviation. It was the vision of Walter Brown, the postmaster general of the Hoover Administration, to have an integrated, competitive airline network spanning the nation instead of a hodgepodge collection of uncoordinated air carriers and flight routes. With mail contracts and almost absolute authority, he managed to set the direction of American aviation for the rest of the 20th century. (Above, Briscoe Center for American History, University of Texas; below, Story Sloane's Gallery.)

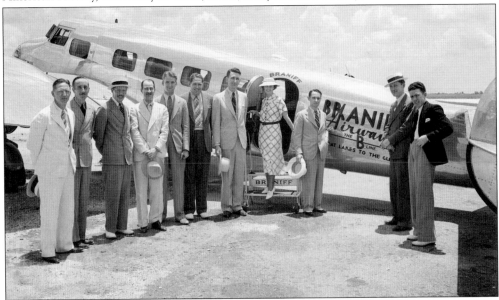

During the competition between the Big Four, United had ordered 60 Boeing 247 aircraft. The twin-engine, retractable-geared airplane was the first modern airliner. With 247s being unavailable in the near future due to the United contract, TWA put out a bid for an alternate aircraft, and the Douglas Aircraft Company designed the DC-1 (Douglas Commercial No. 1) to fulfill the contract. With the first commercial flights of the DC-2 (an improved version of the one-off DC-1) beginning in 1934, it was soon realized that the DC-2, shown here, and its successor, the DC-3, were the benchmark of commercial aviation, surpassing the safety, speed, and passenger capacity of their competitors. After obtaining the financial security of its second mail contract, Braniff introduced its first DC-2 in 1937, to be followed in 1939 by the DC-3. The original seven DC-2s were secured from TWA. (Both, Briscoe Center for American History, University of Texas.)

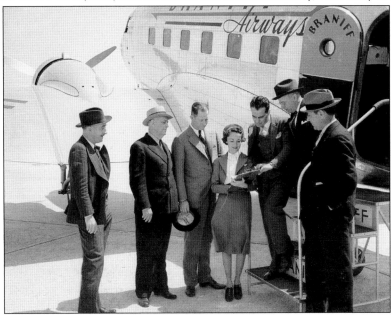

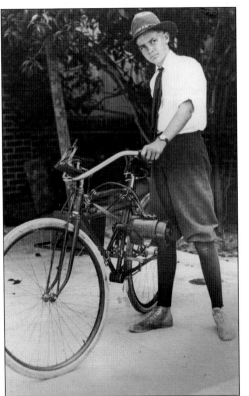

Howard Hughes, possibly Houston's most famous billionaire, inherited his father's oil-drill tool manufacturing business, the Hughes Tool Company, at the age of 18 in 1924. With an interest in technology dating from his earliest years, as shown in this photograph of him at the age of 12 with a motorized bicycle he had built, Hughes moved to Los Angeles a year later. Within five years, he produced *Hell's Angels*, an aviation war film now considered a classic. (RG 1005-1845, Houston Public Library, HMRC.)

Four years prior to Hughes's record-setting round-the-world flight in a Lockheed Super Electra, shown here arriving at the Houston Municipal Airport in 1938, he had competed in his first air race, the All-American Air Meet in Miami, winning the Sportsman Free-for-All category in a Boeing 100A biplane. Establishing the Hughes Aircraft Company, he then built and flew his own creation, the H-1, setting a new world land-speed record of over 352 miles per hour. A nonstop record from Los Angeles to Newark in less than 7.5 hours followed. (Houston Metropolitan Research Center.)

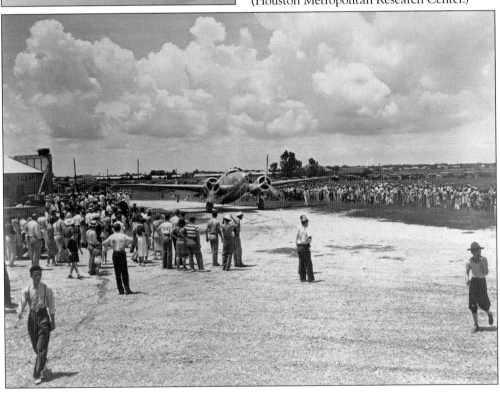

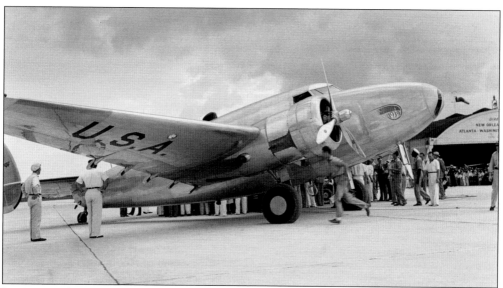

In 1938, Hughes set a round-the-world record of just over 91 hours in a specially modified Lockheed Super Electra, NX18973, named the *1939 New York World's Fair*. Powered by a pair of Wright Cyclone engines producing over 1,100 horsepower, it was equipped with extra fuel tanks, increasing total fuel capacity to over 1,800 gallons, as well as additional radio and navigation equipment. Hughes and his crew left Floyd Bennett Field in New York on July 10, 1938, returning to the same field less than four days later, having traveled via Paris, Moscow, Omsk, Yakutsk, Fairbanks, and Minneapolis. Average speed over the almost 15,000-mile journey was 206 miles per hour. Over 25,000 spectators welcomed Hughes and his crew home. (Both, Briscoe Center for American History, University of Texas.)

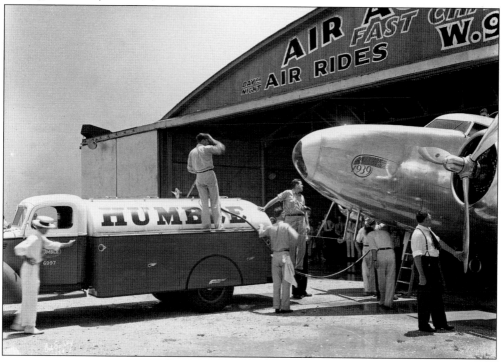

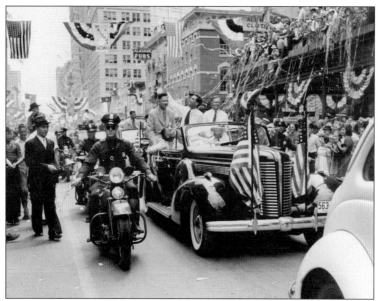

Hughes's crew for his record flight included Richard Stoddart (radio operator), Edward Lund (flight engineer), Harry Connor (copilot), and Thomas Thurlow (navigator), while Albert Lodwick served as the flight operations manager for the journey. Returning to Houston later in July 1938, Hughes and his crew were honored by the city with a ticker tape parade through downtown. For his aviation accomplishments, Hughes was awarded the Harmon International Trophy as the outstanding aviator of the year in 1936 and again in 1938, joining the likes of Charles Lindbergh and Wiley Post. Other honors included the Collier Trophy for achievement in aeronautics and the Octave Chanute Award for outstanding contribution made by a pilot to the advancement of aeronautics. He was also awarded the Congressional Gold Medal in 1939, again joining Lindbergh (awarded in 1928) and the crew of the US Navy's NC-4, the first trans-Atlantic crossing by aircraft (awarded in 1929 for its 1919 mission). (Above, MSS0114-1079, Houston Public Library, HMRC; below, Briscoe Center for American History, University of Texas.)

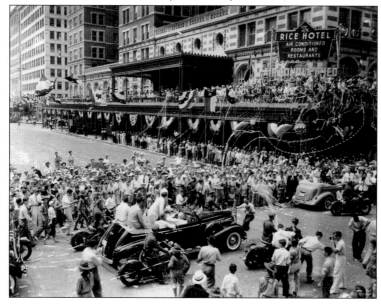

While Hughes was realizing his aviation ambitions, Noah Dietrich, chief executive of Howard Hughes's business ventures, directed the numerous enterprises under the Hughes umbrella, including Hughes Tool and its subsidiary Hughes Aircraft, TWA, RKO Pictures, and Gulf Brewing. In 1957, Dietrich and Hughes acrimoniously separated. Hughes became a recluse, dying in 1976 while, ironically, en route to Houston by aircraft. (RG 1005-1913, Houston Public Library, HMRC.)

While at a banquet at the Rice Hotel celebrating his circumnavigation, the city announced a resolution to rename the Houston Municipal Airport the "Howard Hughes Airport." Shortly afterwards, it was realized that regulations prohibited the granting of federal funds to an airfield named after a living person, so the airport's name reverted to Houston Municipal Airport. (RG 1005-airportnaming095, Houston Public Library, HMRC.)

A RESOLUTION DECLARING THAT THE HOUSTON MUNICIPAL AIRPORT SHALL HEREAFTER BE KNOWN AS THE "HOWARD HUGHES AIRPORT," AND DECLARING AN EMERGENCY.

· · · · · · · ·

WHEREAS, it is the desire of the City Council of the City of Houston to establish a lasting memorial to the name of Howard Hughes in recognition of his world famed accomplishments in the field of aviation; and,

WHEREAS, it is deemed particularly fitting and proper that this be done by naming Houston's Municipal Airport in honor of Howard Hughes;

NOW, THEREFORE, BE IT RESOLVED BY THE CITY COUNCIL OF THE CITY OF HOUSTON:

Section 1: That from and after the passage of this resolution, the Municipal Airport now owned and operated by the City of Houston shall be known as the "HOWARD HUGHES AIRPORT".

Section 2: There exists a public emergency requiring that this resolution be passed finally on the date of its introduction, and the Mayor having in writing declared the existence of such emergency and requested such passage, this resolution shall be passed finally on the date of its introduction, this 30 day of July, A. D. 1938, and shall take effect immediately upon its passage and approval by the Mayor.

Passed this 30 day of July, A. D. 1938

Approved this 30 day of July, A. D. 1938.

Approved:
Will Sears.
Assistant City Attorney.

Mayor of the City of Houston

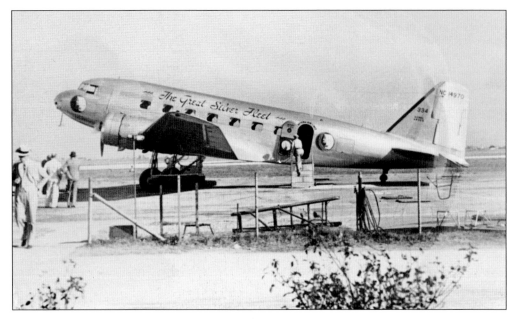

Eastern Air Lines established a station at Houston after purchasing the Wedell-Williams Air Service in December 1936. With the advent of Douglas's commercial aircraft, Eastern bought 14 DC-2s for its eastern seaboard runs. N14970, a Douglas DC-2, shown above, was purchased by Eastern in 1935, leaving the fleet six years later. NC18124, a Douglas DC-3, was one of a group of five purchased in 1937. Both are shown in the livery of "The Great Silver Fleet," a marketing slogan of the president, Eddie Rickenbacker. The eagle logo on the nose dates from 1935. The federally subsidized air mail routes held by Eastern included Nos. 5 (Newark–New Orleans), 6 (Newark–Miami), 10 (Chicago–Jacksonville) and 20 (the original Robertson/Wedell-Williams route of New Orleans–Houston). (Both, Briscoe Center for American History, University of Texas.)

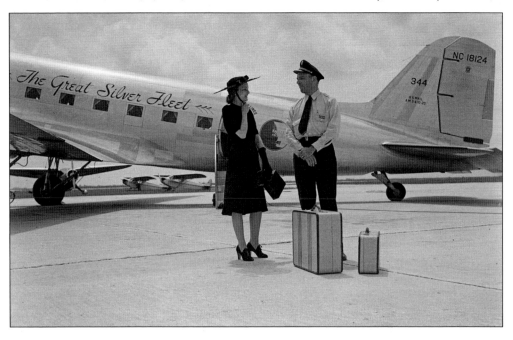

This photograph of the control tower at Houston's airport identifies the airfield as "Howard Hughes Airport Houston, Texas." It is located next to the Eastern hangar showing an advertisement for direct service to New Orleans, Atlanta, Washington, New York, Jacksonville, and Miami. (1940 Air Terminal Museum.)

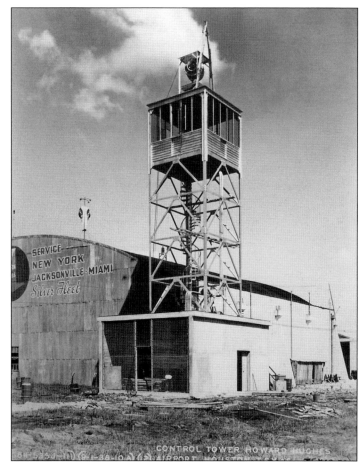

The light-colored terminal building at Houston Municipal Airport is shown in the distance with an Essair Airlines Consolidated Model 20 Fleetster at left, a biplane at center, and a gull wing Stinson Reliant, a four-to-five seat cabin aircraft, at right. (Michael Bludworth.)

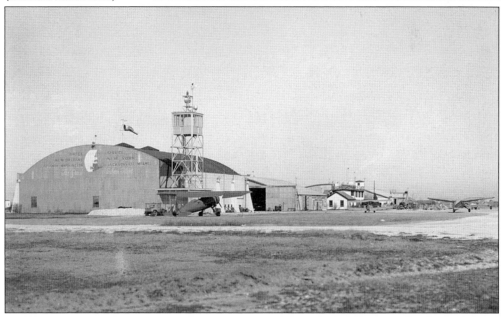

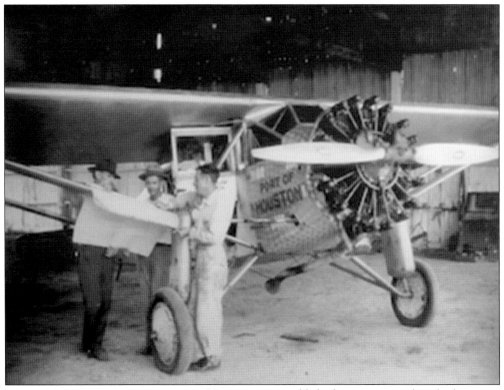

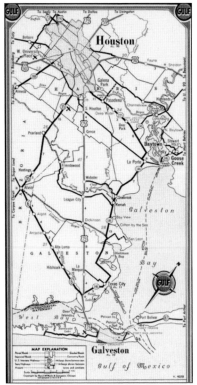

Houston was established as a port city, but the bayou that served the community lacked the depth required for larger vessels, so cargo had to be barged to and from Galveston. The city turned to Washington to assist in funding a 52-mile deepwater ship channel to Houston. Opening in 1914, it became the catalyst for the economic development of the greater Houston area. Besides handling bulk and containerized cargo, it serves a variety of petrochemical industries. An aircraft, such as this Ryan B1, offered both staff transport and aerial port and vessel observation. (Michael Bludworth.)

Gulf Refining Company of Texas was another oil company born out of the Spindletop boom. Originally planning to be called the Texas Oil Company, it had to settle for the alterative of Gulf after realizing that the Texas moniker had been claimed weeks earlier. Its mid-century road map shows Galveston's Fort Crockett and the island's airport, once named Corrigan Airport after Douglas "Wrong Way" Corrigan, the transatlantic aviator, at the bottom of the map. Houston Municipal Airport is center-top near State Highway 35 (Telephone Road) with the Main Street Airport shown at the upper left. After a number of years in remission, the historic Gulf brand and its orange disc trademark have returned nationally. (Michael Bludworth.)

Four

THE 1940S

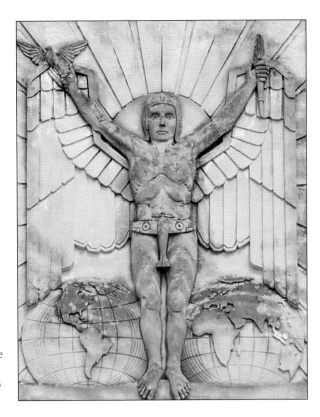

By 1937, the Houston Municipal Airport had, for the second time, grown beyond the capabilities of its wooden terminal, and a new Art Deco–influenced structure was designed to handle passenger traffic. Mounted above the entrance to the terminal, the winged god Mercury greeted arriving passengers to Houston. (Michael Bludworth.)

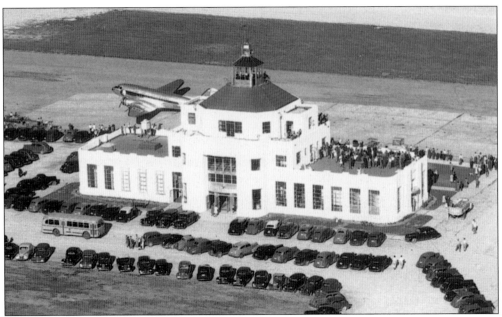

On September 28, 1940, the City of Houston formally opened its newest terminal at the Houston Municipal Airport. Having purchased the airfield in 1937, the city retained Joseph Finger, an Austrian immigrant, to design and build a state-of-the-art terminal. Finger's reputation in the design of commercial and public structures in the Gulf area was complemented by his architectural work within Houston's Jewish community, including Congregation Beth Israel Temple (1925) and Mausoleum (1935) and Congregation Beth Yeshurun Synagogue (1949). Serving as an administration facility for the airport, the terminal included overnight crew quarters, a radio room, a lighted tower, a modern weather station, observation decks, and a café. Housing was constructed nearby for airfield personnel. Two scheduled air carriers, Braniff Airways and Eastern Air Lines, provided service to Houston in 1940. The public ceremony dedicating the new terminal featured Douglas DC-3s from both carriers on display. (Both, 1940 Air Terminal Museum.)

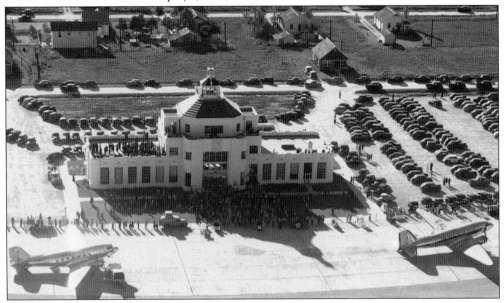

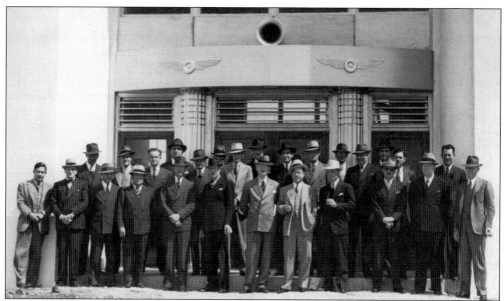

Above are the city fathers, including the terminal's designer, Joseph Finger (front row, fifth from right), gathered for a photograph at the entrance to the new terminal prior to its opening. M.R. Van Valkenburgh, the structural engineer, is in the second row, fourth from left. The two dozen plus aircraft in the terminal area that day included a Braniff DC-2; a Northrop Delta, operated by Baker Oil Tools; three Gullwing Stinson's, one owned by the Texas Pipeline Company; a Fairchild 45; three Fairchild 24s; a Taylorcraft; a Piper Cub; and a Waco biplane. The modern airport terminal also became a backdrop for a variety of promotional photographs, such as the one below that includes an Eastern DC-3 with a Lincoln Zephyr auto and model. (Above, Michael Bludworth; below, Briscoe Center for American History, University of Texas.)

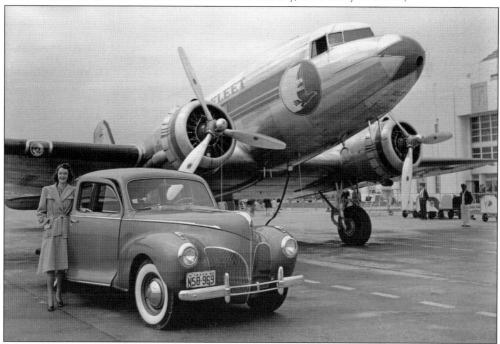

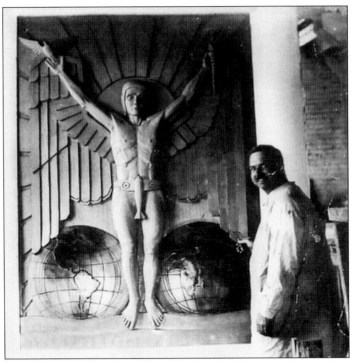

Artist Dwight Holmes is pictured with one of two *Winged Mercury* friezes that he created for the main entrances to the Houston Municipal Airport terminal. Holmes, after attending Texas Christian University, worked as a modeler, with his architectural reliefs and murals decorating public buildings in Texas and the Gulf states. Known for his landscapes, he painted throughout the Southwest and in Mexico, settling in San Angelo, Texas. The bas-relief at left shows the Greek god Mercury with the dove of peace and the torch of knowledge, while his headgear evokes an aviator's leather helmet. The bas-relief below was one of three that were repeated as part of the frieze placed at the top of the first level of the building. Representing a history of aviation, this one symbolized early aviation, showing an airframe design similar to a Wright flyer. (Both, Michael Bludworth.)

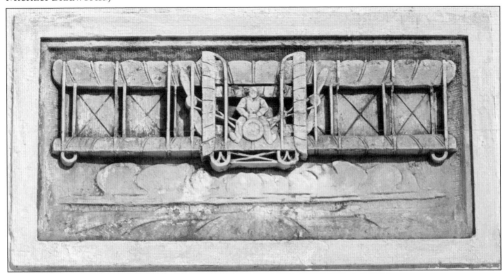

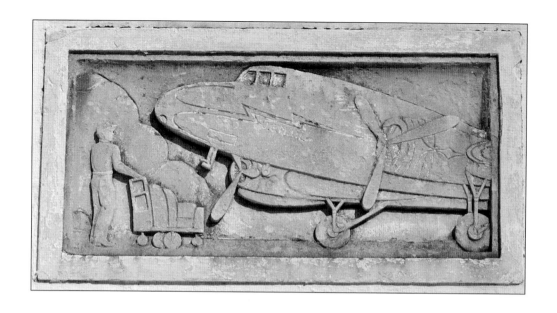

The two bas-reliefs pictured were part of three repetitively encircling the terminal as part of the decorative frieze. The image above shows a contemporary twin-engine aircraft with a baggage cart of cargo, possibly airmail, and "US Mail" as part of the airframe's livery. For American aviation, the federal government's subsidy of air carriers transporting mail on various national routes in the 1930s was critical to the development of modern passenger transport. The image below shows an imaginative aviation future with an autogiro-influenced aircraft in flight with an airfield hangar in the background along with a tower believed to represent progress in radio technology. (Both, Michael Bludworth.)

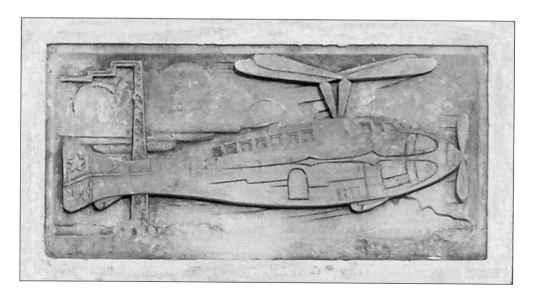

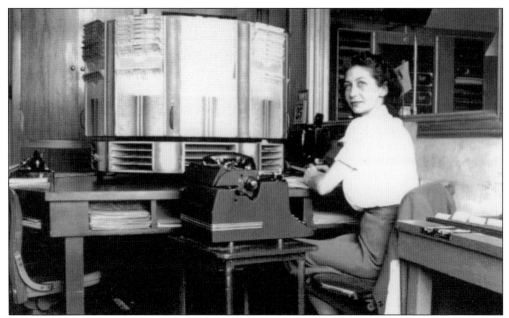

Ms. Runnels and Ms. Thompson of Eastern Air Lines are shown working the Eastern reservation desk at the terminal in the early 1940s. They would have been working out of a room on the north side of the terminal lobby directly behind the Eastern ticket counter, taking tickets and helping customers as needed. Though pilots, and later stewards and stewardesses, became the public face of the airline industry, it was also the unacknowledged ground personnel, including mechanics and reservations and operations personnel, who functioned behind the scenes and kept the aircraft flying. At Eastern, for example, pilots made up less than 10 percent of the employees in the late 1980s. (Both, 1940 Air Terminal Museum.)

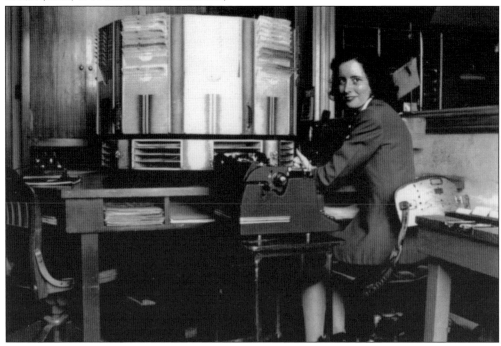

Katy Fuller, another Eastern employee, is shown on a rotary telephone. All phones were rotary until 1963, when the touch-tone phone was invented. Prior to computers and the Internet, the post, radio, and the telephone were the primary means of long-distance communication, with the telephone offering both immediacy and convenience unavailable via mail or wireless. (1940 Air Terminal Museum.)

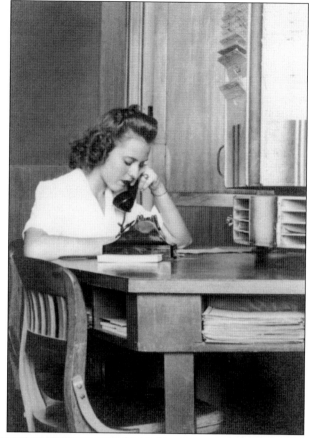

Radio operator Howard Lineberger is seen at Eastern Air Lines' 1,000-watt receiving and transmitting set, one of 53 company-owned ground stations at the time. These machines transmitted and received messages to and from all company planes and offices for weather forecasts and flight movements, and helped with reservations. The ground radio unit was located on the north side of the terminal, separated from the reservation desk by a partition wall. (1940 Air Terminal Museum.)

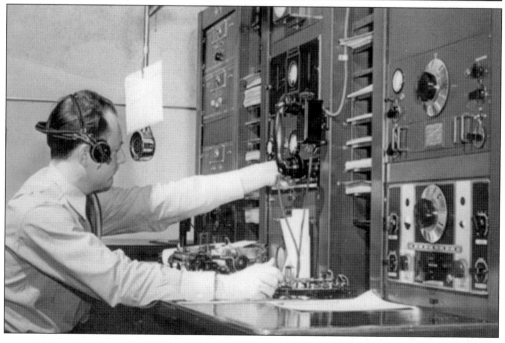

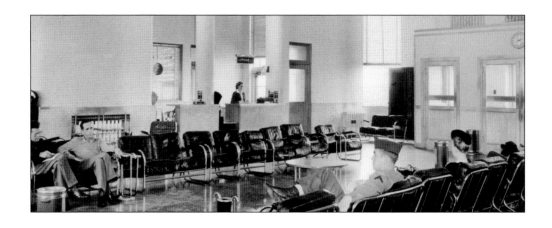

The Houston Municipal Airport terminal lobby is shown looking north toward the Eastern Air Lines ticket counter. The passenger sitting to the left appears to be Humphrey Bogart, the Academy Award–winning actor famous for his roles in *The Maltese Falcon*, *Casablanca*, *The African Queen*, and *The Caine Mutiny*. The area immediately behind the flagpole in the postcard below was the location of the Eastern ticket counter. Holmes's *Winged Mercury* is visible above the entrance. Though the new terminal was constructed with a concrete apron for transiting aircraft, Houston's city council only committed to replacing the crushed shell gravel runways after pressure from Eastern's president, Capt. Eddie Rickenbacker, the World War I flying ace turned airline executive. With two runways paved by the end of the war, the airlines no longer had to worry about a fully loaded DC-3 sinking to its axles in mud after a hard rain. (Above, 1940 Air Terminal Museum; below, Michael Bludworth.)

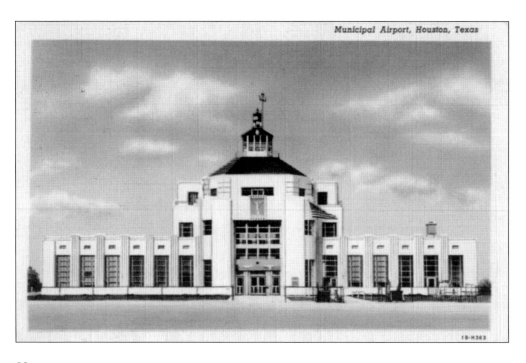

Aviation Enterprises, formed by former Houston Transportation Company corporate pilot Earl McKaugh and former Republic Oil company corporate pilot Henry Erdman, sold and serviced new Stinsons, Fairchilds, and Spartans to local oil industry companies. Along with the construction of the new terminal, a modern hangar was built and leased to Aviation Enterprises. With the formation of the Women's Auxiliary Ferrying Squadron (WAFS) in mid-1942 to provide trained women aviators to ferry military aircraft, Aviation Enterprises bid on and won the federal contract to train the WAFS pilots and continued to do so after the squadron moved to Avenger Field at Sweetwater, Texas. Aviation Enterprises also overhauled and rebuilt PT-19 trainers across Texas, serving as a civilian Air Depot Detachment for the Army. By the end of the decade, Aviation Enterprises had started the Houston-based Trans-Texas Airways. The large hangar still stands and continues to be leased to United Airlines, the successor to Trans-Texas. (Both, Michael Bludworth.)

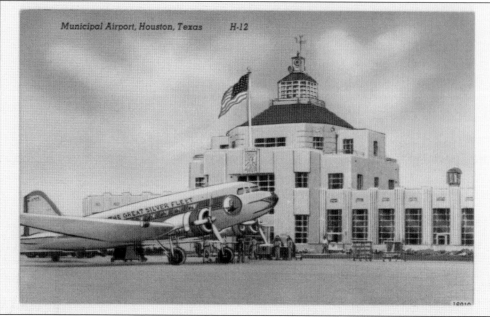

Eastern Air Lines was one of two major carriers originally operating out of the Houston Municipal Airport when the new terminal opened in September 1940. Eastern's service included the Douglas DC-2 and DC-3, as well as the elegant Douglas Sleeper Transport. "DST" passengers boarded their flight at the terminal in the evening, enjoyed a fine meal served on china, and retired to their Pullman-style berths for the night. In the morning, passengers would be served breakfast while airborne near Washington, DC, then arrive in New York City by mid-morning. After the war, Eastern modernized its service to Houston with the Douglas DC-4, the Lockheed Constellation, and the Martin 4-0-4. Eastern remained one of Houston's most important airlines until its liquidation in bankruptcy in 1991. The prominent location of the flagpole in the postcard above is different than its actual location, shown in the photograph below. (Above, Michael Bludworth; below, Briscoe Center for American History, University of Texas.)

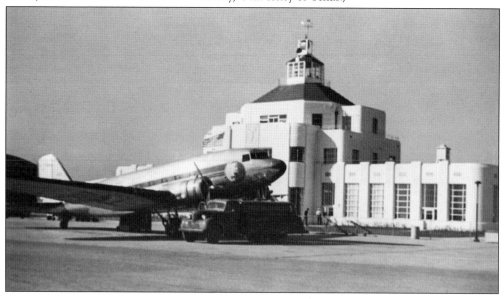

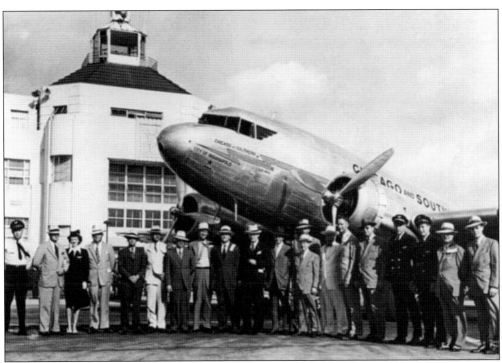

In 1941, the Civil Aeronautics Board awarded Chicago & Southern Air Lines, a carrier operating along the Mississippi River valley, a route into Houston from Memphis, Tennessee. C&S became the third trunk airline operating from the new terminal. C&S had started as the Pacific Seaboard Air Lines operating between Los Angeles and San Francisco but after winning the airmail contract between Chicago and New Orleans in 1934, operations were shifted to the Midwest, and the company's name was appropriately changed. Within five years of operating in Houston, C&S was awarded a route to Havana, later followed by service to San Juan, Puerto Rico, and Caracas, Venezuela, providing international service for Houston patrons. Yet by 1953, economic difficulties led to a merger with Delta Airlines with the livery of the combined fleet bearing both names for a number of years: Delta–C&S Air Lines. (Above, Michael Bludworth; below, Delta Airlines.)

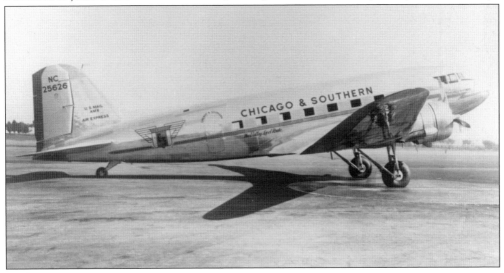

With hostilities breaking out in East Asia and in Europe, Ellington Field was reopened by 1940. Aviation cadets James Grove (left) and his twin brother, Roland, departed the Texas oil fields and enlisted prior to the attack on Pearl Harbor. They were first posted to Ellington as aircraft mechanics, eventually being trained as pilots in the Air Corps. Jim was shot down over North Africa while flying a P-38. Roland flew transports out of New Guinea and the South Pacific, surviving the war. (US Air Force.)

Ellington was one of the largest preflight training units for bombardiers and navigators and was a location for advanced flight training for bombing pilots and bombardiers. By late 1943, it also hosted an Advanced Navigation School, a function that continued into the postwar years. The Cessna AT-17 Bobcat, used as a military trainer, was a military version of the Cessna T-50 transport. Powered by twin Jacobs radial engines and with an airframe of wood, over 5,000 Cessna AT-17 Bobcats saw allied military service. (US Air Force.)

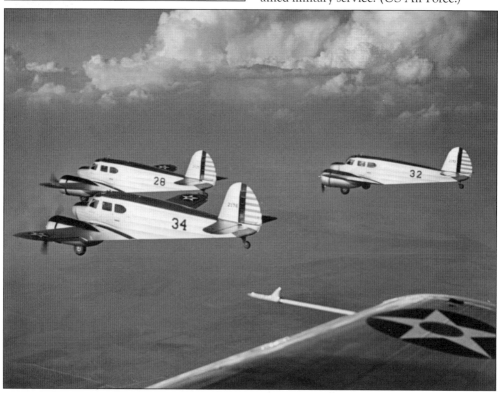

As men volunteered or were conscripted for military service, the nation faced a critical shortage of labor; their spouses, mothers, and daughters stepped in to fill the void. Joy Richards was one of the first female mechanics serving on Ellington Field, helping to keep the twin-engine trainers airborne. Almost 500,000 women worked in the aircraft industry alone, with another 350,000 serving in uniform, both in the states and overseas. From shipyards to foundries, warehouses to hospitals, 12 million women served in the nation's defense industry or support services. (US Air Force.)

The Beechcraft AT-7 Navigator, a variant of the Beechcraft 18, was utilized for navigation training during World War II. Equipped with an astrodome and seating for three students, over 1,000 were built. The bombardier training version of the "Twin Beech" was the AT-11 Kansan; equipped with .30-caliber machine guns, it was also used for gunnery training. The transport version was known as the C-45 Expeditor. The flight of three is photographed passing over the 567-foot San Jacinto Monument commemorating those who fought for Texas independence. (Briscoe Center for American History, University of Texas.)

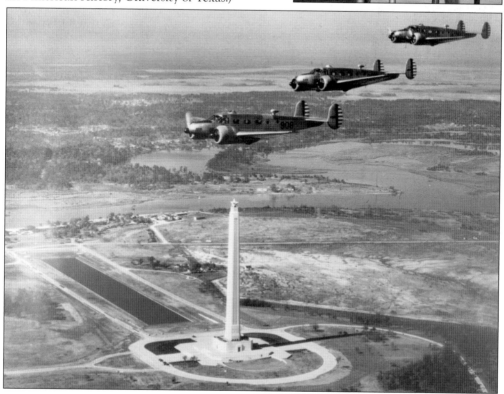

The photograph above was taken from the stands at Ellington Field as the largest graduating class in the history of the flying school prepared to receive their wings. Pictured below are cadets passing in review carrying the flags of the Allied nations. With the end of war, Ellington Field first became a National Guard and Air Force Reserve site and then was reactivated as Ellington Air Force Base with a radar-navigation school eventually serving as a tenant unit; over 10,000 students completed training at the radar-navigation school. With the establishment of the Manned Spacecraft Center in 1961, NASA utilized the field for astronaut training; bought by the City of Houston, Ellington Field Joint Reserve Base now also houses a variety of Reserve and Guard units as well as a Coast Guard Air Station. (Both, US Air Force.)

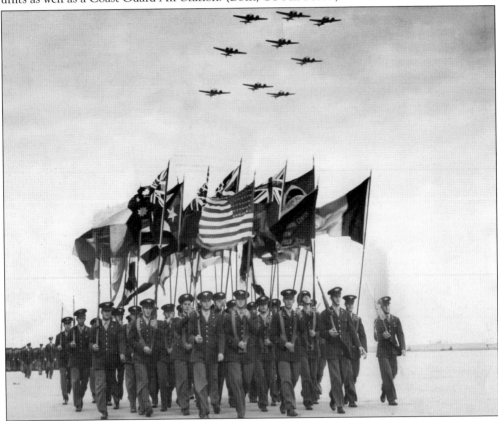

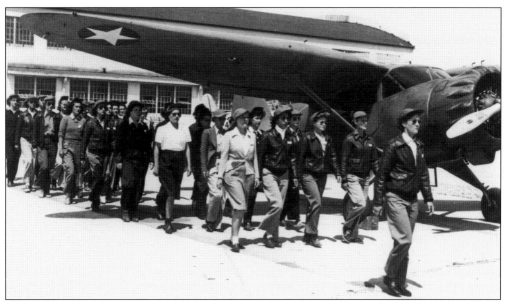

In 1939, Jacqueline Cochran, famous for her 1930s aviation racing accomplishments, presented the idea of using women pilots for non-combat stateside aviation missions to the military, only to be turned down. The following year Nancy Harkness Love, a commercial pilot and operator of an aviation service and sales facility, suggested that experienced women aviators could ferry aircraft, allowing commercial pilots to fulfill military duties. She too was rejected. Yet by mid-1942, Love's concept of experienced women ferry pilots was accepted and the Women's Auxiliary Ferrying Squadron (WAFS) was publicly announced. This instigated the immediate approval of Cochran's broader plan of military flight training and duties extending beyond ferrying assignments. The Women's Flying Training Detachment (WFTD) was created, with Jacqueline Cochran as director. By November, the first class of 28 women pilots reported for training at Houston Municipal Airport, with a second class arriving a month later along with some military PT-19 and BT-13 training aircraft. (Both, Texas Woman's University.)

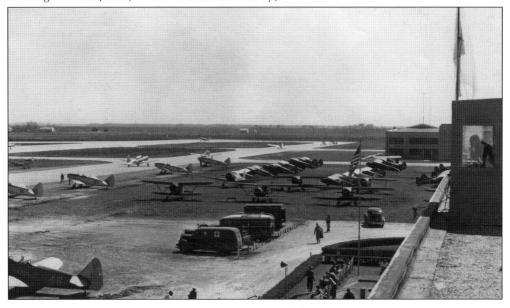

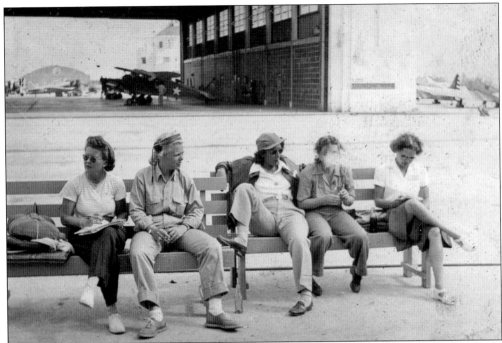

While Nancy Love's experienced pilots (eventually over two dozen women) started four weeks of transition training in Delaware, Jacqueline Cochran's proposal led her to Houston Municipal Airport. With Aviation Enterprises securing the contract for training the pilots, the first volunteers (more than 25,000 applied) came from across the country at their own expense, the WFTD being considered a civilian organization though operating under military supervision and direction. More than 1,800 were eventually accepted, and almost 1,100 graduated. Many of the volunteers had family members serving in the military. Originally required to have a pilot's license and flight experience, the flight-time requirement for induction was later lowered. At Houston, the original training fleet included 22 different kinds of civilian aircraft, eventually replaced by military trainers. Volunteers included Mary Tufts Trotman (O'Brien) [Class 43-W-2], Marie Shale [43-W-3], Frances Dias (Gustavson) [43-W-2], Zelda Lamer [43-W-2], and Ruth Grimm Trees [43-W-2]. (Both, Texas Woman's University.)

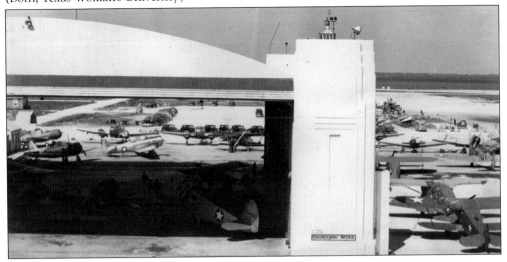

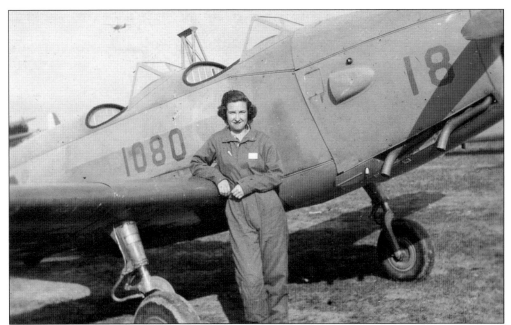

The flight training was initiated with civilian light aircraft, such as a Piper Cub or a Taylorcraft, used to determine that the pilots were prepared for the 175-horsepower Ranger-powered PT-19 Cornell, nicknamed the "Vibrator." Following the aviation training curriculum of the military (minus gunnery instruction), the training included ground school, where the basics of aerodynamics, meteorology, communications, navigation, and military policy and procedures were taught. The 500-plus hours of ground school were integrated with approximately 200 hours of flight training, with students moving from the primary trainers on to the BT-13 basic trainers. Developed by Fairchild in 1938, almost 5,000 PT-19s, shown above with Elisabeth "Betty" Whitlow (Smith) [43-W-2], were manufactured, along with another 2,000 versions with canopies (PT-26) and radial engines (PT-23). The BT-13 Valiant, below, introduced in 1940, was the predominant basic trainer for the Air Corps. Originally equipped with a 450-horsepower Pratt & Whitney powerplant, versions with 450-horsepower Wright Whirlwinds were designated BT-15. (Both, Texas Woman's University.)

Instrument training started with time in the Link Trainer, a simulator that allowed trainees to make mistakes without endangering themselves. Each trainee spent approximately 30 hours in the Link, with five hours of primary training for familiarization with using instruments, another 15 hours of basic training simulating rough weather flying, and the introduction of some radio navigation work. Advanced instruction followed, with techniques needed to use radio navigation beacons. Students learned instrument landing procedures and simulated "cross-country" flights. The insignia of the WASPs, Fifinella, also known as Fifi, is seen on the side of the nearest Link. Designed by the studios of Walt Disney, Fifinella, a female gremlin from Roahl Dahl's book *The Gremlins*, became the mascot of the WASPs. The photograph below shows the tight working conditions trainees dealt with in Houston prior to the program being moved to Avenger Field. (Both, Texas Woman's University.)

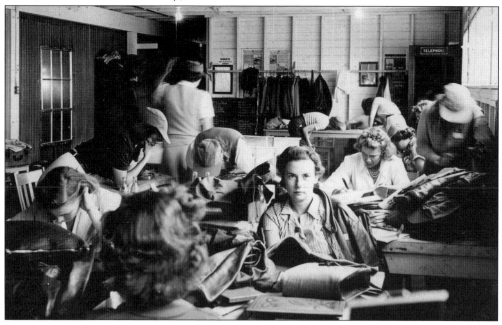

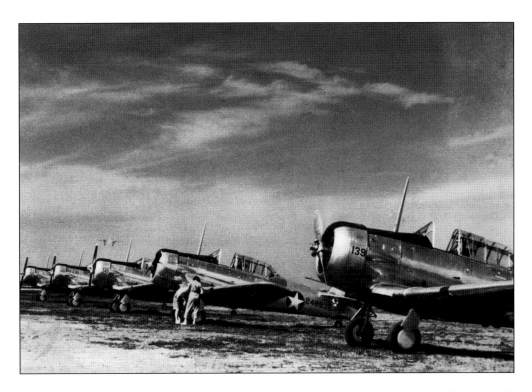

Advanced training was in the 600-horsepower North American AT-6 "Texan." Over 15,000 aircraft were built in various versions for both US and Allied forces between 1938 and 1945. Training continued with the twin-engine AT-17 Cessna Bobcat. The first three classes of WFTD started training at Houston (as did one-half of the fourth class), but only class 43-W-1 would graduate in Houston. By May 1943, the rest were transferred to Avenger Field in Sweetwater, Texas, flying their training aircraft to the new base. Two months later, the WFTD and the WAFS consolidated, becoming the Women's Airforce Service Pilots (WASP). Thirty-eight WASPs would die during the organization's two years of existence. Besides ferrying almost the entire spectrum of aircraft in Army Air Force inventory, from liaison planes to B-29s, WASP missions also included flight instruction, gunnery target and glider towing, flight-testing, and flying radio-controlled airplanes. It would be 40 years before Congress finally authorized veteran status for the WASPs. (Both, Texas Woman's University.)

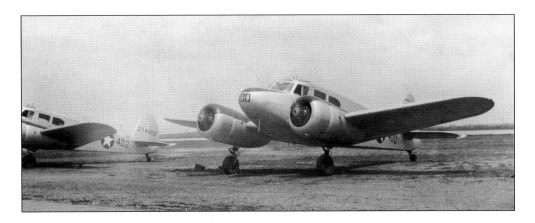

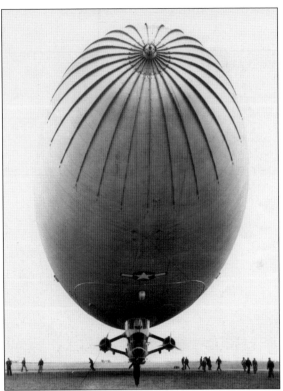

When the Nazi submarine attacks on American shipping off the coast of the United States in 1942 led to the sinking or damage of over 70 ships from Maine to Florida—the numbers reaching over 230 ships sunk off the East Coast and in the Gulf with the loss of 5,000 passengers and crew by mid-1942—the US Navy established nine new bases along the coast to house lighter-than-air craft to interdict the enemy boats. (Hitchcock Public Library.)

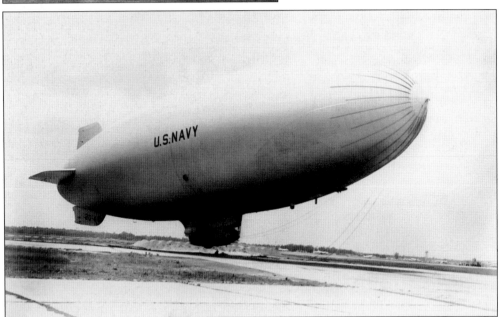

Popularly known as blimps, these nonrigid airships were used as an antisubmarine patrol force to locate the attacking German U-boats. By the end of the war, almost 170 blimps were used in operations along the US coast, in the Caribbean, and overseas, with over 130 being the modern twin-engine K-class airships. Hitchcock, 35 miles south of Houston in Galveston County, became the location of one of those airship bases. (Hitchcock Public Library.)

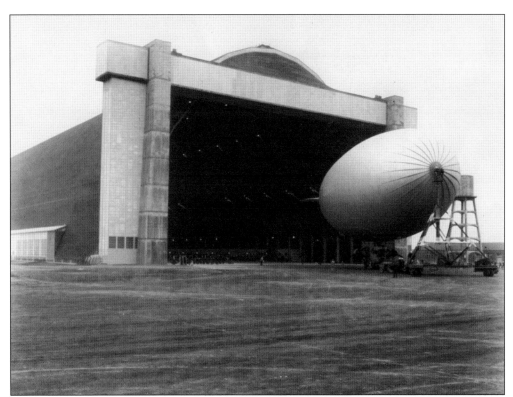

To house the squadron of blimps, an $8.5 million hangar large enough to house six airships was constructed. Started in 1942, the 1,000-foot-long, 300-foot-wide, and 200-foot-high wooden hangar was completed in the spring of 1943. The blimps were moved on-site via a 42-foot portable mooring mast mounted on pneumatic tires. (Hitchcock Public Library.)

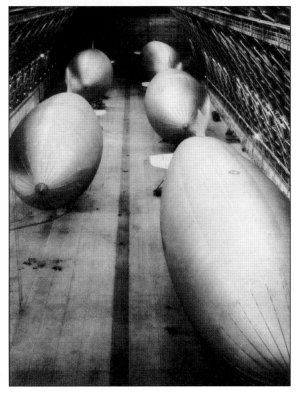

Supported by four 200-foot concrete corners, the hangar utilized wood as a substitute for the critically needed metal normally used in contemporary hangar construction. Commissioned on May 22, 1943, 133 men were originally assigned to the lighter-than-air (LTA) base. Crews of about 40 personnel were required for docking, walking the 252-foot-long Goodyear-constructed airships into and out of the hangar. (Hitchcock Public Library.)

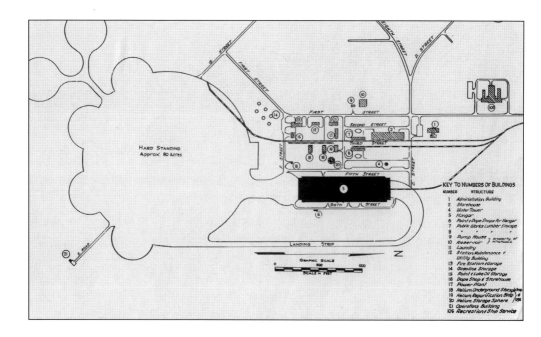

Built on 3,000 acres of coastal plain, Naval Air Station Hitchcock consisted of 47 buildings including the blimp hangar itself, the administration office, living quarters, and a recreation building holding an auditorium, gymnasium, stage, dressing rooms, kitchen, and an Olympic-size swimming pool. A sphere to store the nonflammable helium required to inflate the blimps was also installed. The asphalt-paved landing area, which included a landing strip, comprised nearly 80 acres alone. The squadron, ZP-23, also leased an auxiliary field at San Benito, Texas, approximately 10 miles north of Brownsville and the Mexican border, allowing for the extended deployment of an airship to the southern Texas coastal area 300 miles distant. (Both, Hitchcock Public Library.)

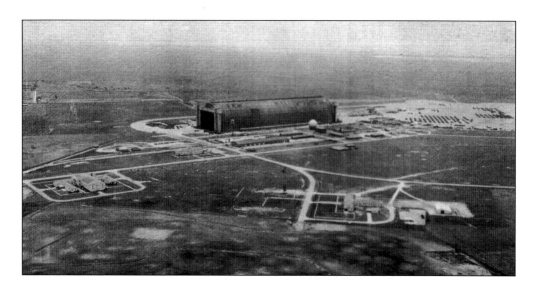

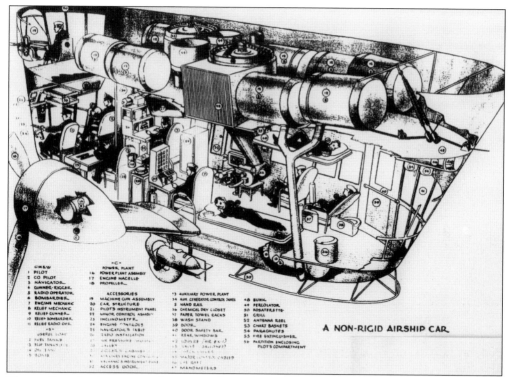

CREW	POWER PLANT	43 AUXILIARY POWER PLANT	48 BUNK
1 PILOT	16 POWER PLANT ASSEMBLY	44 AUX. GENERATOR CONTROL PANEL	49 PERCOLATOR
2 CO PILOT	17 ENGINE NACELLE	5 HAND RAIL	50 ROASERETTE
3 NAVIGATOR	18 PROPELLER	56 CHEMICAL DRY CLOSET	51 GRILL
4 GUNNER-RIGGER		57 PAPER TOWEL RACKS	52 ANTENNA REEL
5 RADIO OPERATOR	ACCESSORIES	58 WASH STAND	53 CHART BASKETS
6 BOMBARDIER	19 MACHINE GUN ASSEMBLY	59 DOOR	54 PARACHUTES
7 ENGINE MECHANIC	20 CAR STRUCTURE	40 DOOR SAFETY BAR	55 FIRE EXTINGUISHER
8 RELIEF MECHANIC	21 PILOT'S INSTRUMENT PANEL	41 REAR WINDOWS	56 PARTITION ENCLOSING
9 RELIEF GUNNER	22 MINOR CONTROL ASSEMBLY	42 LOUVER / AIR 8x/2	PILOT'S COMPARTMENT
10 RELIEF BOMBARDIER	23 INCLINOMETER	43 VALVE / BALLONET	
11 RELIEF RADIO OPR.	24 ENGINE CONTROLS		
-43-	25 NAVIGATOR'S TABLE		
USEFUL LOAD	26 RADIO INSTALLATION	45 MAJOR CONTROL CABLES	
2 FUEL TANKS	27 UK PRESSURE	46 LIFE RAFT	
3 SLIP TANKS	28 GALLEY	47 MANOMETERS	
4 OIL TANK	29 BALLOON CABLES		
5 BOMBS	30 MECHANICS ENGINE CONTROL		
	31 MECHANIC'S INSTRUMENT PANEL		
	32 ACCESS DOOR		

A NON-RIGID AIRSHIP CAR

The roofless aluminum control car, mounded to the base of the envelope, carried a crew of 10 naval personnel including the pilot, two copilots, a navigator, two radiomen, two mechanics, a rigger, and an ordnanceman. With an extended range exceeding 2,000 miles, an airship could cruise at 60 miles per hour or slow down to 30 miles per hour operating at 100 feet for antisubmarine duties. The blimps had the ability to fly low and slow with a loiter capability unsurpassed by fixed-wing patrol aircraft allowing air-sea transfer of equipment and personnel, if needed. Equipped with magnetic anomaly detection (MAD) equipment, sonobouys, and an ANG-type radar unit along with four Mk 47 depth charges and a .50-caliber machine gun, more than one airship took on a German U-boat while waiting for attack aircraft to respond. The acting executive officer, Lt. D.K. Cloniger, is seen below in front of a number of Curtiss-Wright SB2C Helldivers, the Navy's last dive-bomber. (Both, Hitchcock Public Library.)

95

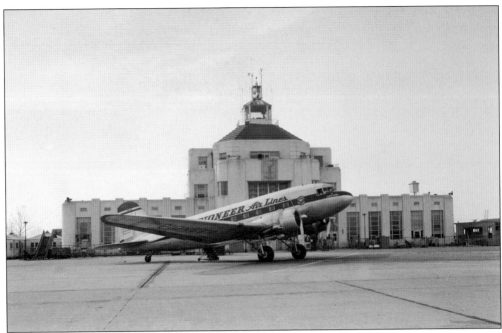

With the end of the World War came the end of wartime travel restrictions, and with commercial airlines on solid footing thanks to both historic airmail subsidies and years of military contracts for the carriage of cargo and passengers, further aviation growth came in serving smaller communities. One of the first to do so was Essair out of Houston. Initiating service from Houston to Abilene in 1945, the airline had appropriately changed its name to Pioneer Air Lines within a year. Eastern and Braniff continued to service Houston, with Braniff eventually changing its trade name to Braniff International Airways in 1946 after having acquired routes to Havana and onward to South America in direct competition with Pan Am. Below, a Braniff DC-4, photographed at Houston Municipal Airport, is at far right in the original Braniff International livery. Pioneer would merge with the Denver-based Continental Airlines in 1955. (Both, Briscoe Center for American History, University of Texas.)

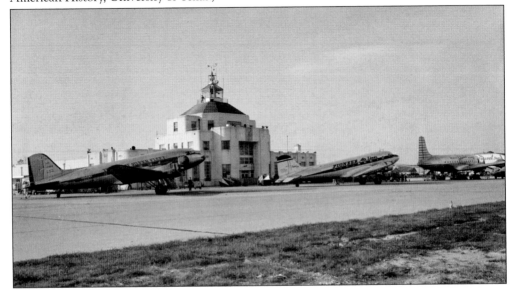

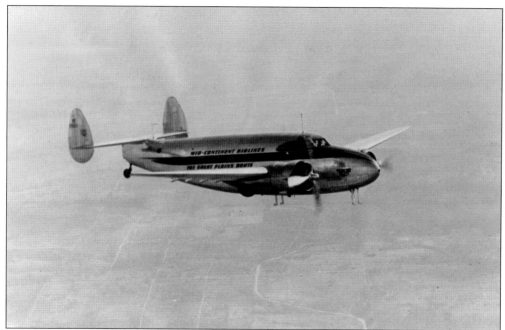

Mid-Continent Airlines, another small airline started in 1938 and headquartered in Kansas City, entered the Houston market in 1946. Originally Hanford Tri-State Airlines, later changed simply to Hanford Airlines, it became Mid-Continent in 1938. Prior to extending its routes southward from Tulsa to Houston, Mid-Continent flew north to Bismarck and Minot, North Dakota, as well as Minneapolis–St. Paul. One of the more unusual airlines to operate out of Houston was Mercury Airlines. Operating between the Dallas–Forth Worth area and Houston, Mercury was founded by Temple Bowen using Douglas DC-3s. Bowen, the owner of the Continental Trailways bus company and former executive of Texas Air Transport and Bowen Air Lines, established Mercury in an attempt to absorb Trailways profit subject to the wartime Excess Profits Tax. After the abolishment of the tax in 1947, Trailways executives dissolved the profitable Mercury. (Both, 1940 Air Terminal Museum.)

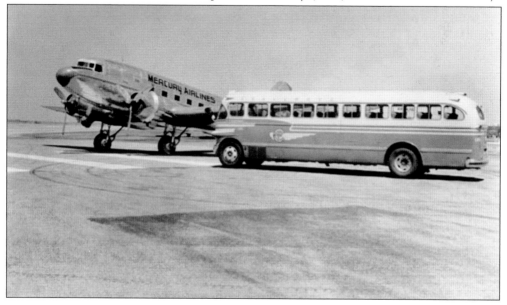

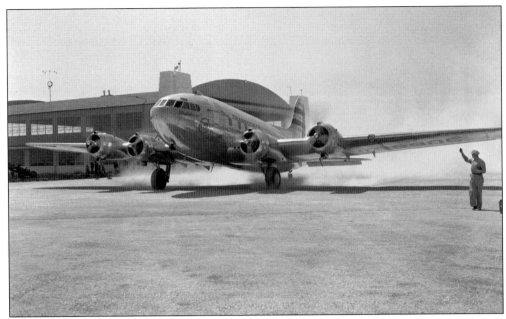

An unusual logo to be seen in Houston was that of TWA—Transcontinental and Western Air, later Trans World Airlines—seen here on a Boeing 307 Stratoliner taxiing at Houston Municipal Airport as part of the new terminal's opening day celebrations. The principal stockholder of TWA, Howard Hughes, would use a four-engine Stratoliner, the first pressurized commercial aircraft, as personal transport. Less than a dozen were constructed prior to the start of World War II, construction of combat aircraft by Boeing having priority thereafter. Originally designed for 33 passengers, the interior of Hughes's personal 307 was redesigned by the famed industrial designer Raymond Loewy. Other aircraft that transited Houston Municipal Airport included the Civil Aeronautics Administration's own Douglas DC-3. The CAA shared responsibility for the safety of the nation's aviation system with the Civil Aeronautics Board (CAB). (Both, Briscoe Center for American History, University of Texas.)

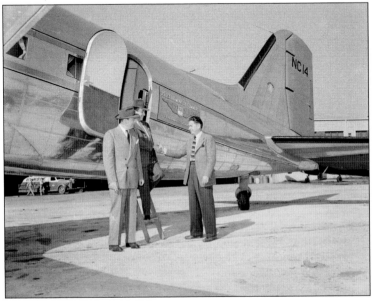

With the postwar growth of airline travel, the industry sold their tickets where their customers lived, worked, and shopped. Ticket counters could be found at downtown hotels such as this one located at the Rice Hotel in Houston. The advertisements marketed technology and the mantra of progress both in their anniversary posters and with models of their Lockheed Constellation on the counter. (Briscoe Center for American History, University of Texas.)

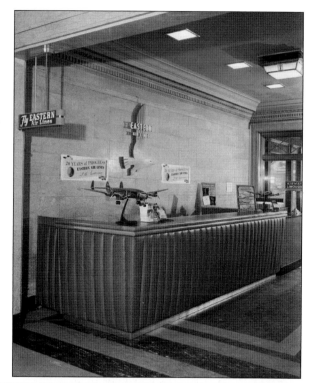

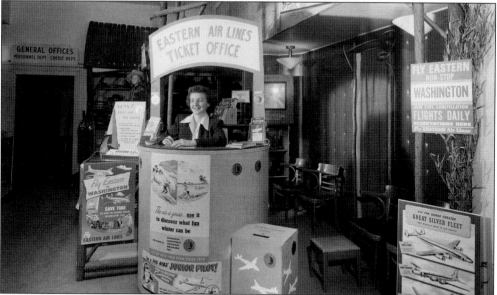

Another Eastern kiosk was located in a children's clothing section of Byrd's department store in downtown Houston. At least one former naval aviator believed that by locating information kiosks in such locations, the industry could overcome the fear of flying many people held at the time. The industry also targeted ads toward the media to influence how aircraft accidents were presented; with 199 passengers killed in 1947—not counting another 882 killed in general aviation aircraft accidents—accidents made for good copy, but bad advertising. (Briscoe Center for American History, University of Texas.)

Hedda Hopper, the Hollywood gossip columnist famous for her trademark flamboyant hats, is shown in a promotional photograph for the Sakowitz Brothers department stores in front of the renamed Houston International Airport terminal. After her visit to a millinery show in Houston, she was flown home by oilman Glen McCarthy in his personal Boeing 307, Howard Hughes's former plane. (Briscoe Center for American History, University of Texas.)

The millinery show hosted at the Shamrock Hotel was also an excellent advertisement for Eastern's Constellation service and no less so for the Ford Motor Company in 1949. The "Connie," built by Lockheed to fulfill TWA's need for a transcontinental airliner, entered Eastern service with the 649 model, later followed by the L-1049 Super Constellation. Over 800 Connies were built before being replaced by jet-engine aircraft in the late 1950s. (Briscoe Center for American History, University of Texas.)

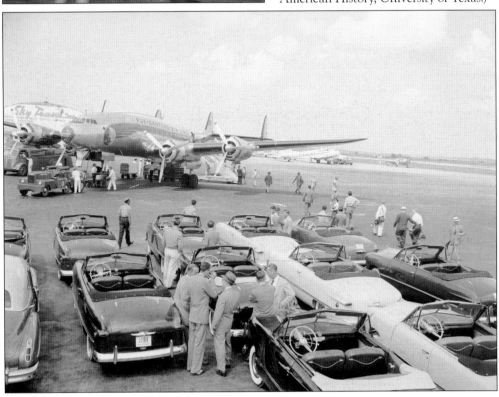

Developed by Stanley Hiller in the late 1940s, the two-seater Hiller 360, shown here being demonstrated in front of Houston's Shamrock Hotel, became the first commercial helicopter to complete a transcontinental flight. The Army acquired 1,600 of the improved version, the UH-12, originally designating them the H-23 Raven. A 180-horsepower Franklin engine powered the original Hiller. (Briscoe Center for American History, University of Texas.)

Foley's department store, an institution in the Houston business community since 1900, used a Bell 47B helicopter for promotional purposes at its Main Street store in 1947. The 47B was a two-seat commercial version of the Bell 47 with enclosed fuselage and tail boom. Powered by a Franklin engine, a later version with a bubble canopy was acquired by the Army as the three-seat H-13. The H-13s most famous use was in a medical evacuation role with an external stretcher mounted on each side of the fuselage. (Briscoe Center for American History, University of Texas.)

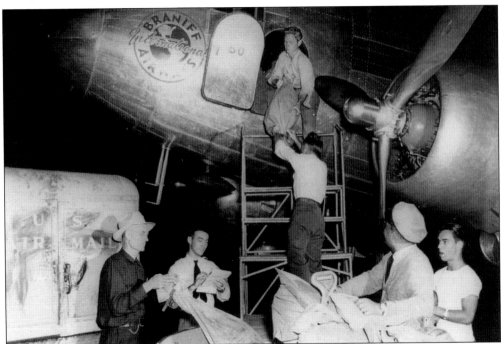

In 1946, the first postwar airmail stamp of 6¢ was introduced, and the first shipment using this stamp from Houston is shown above on an outbound Braniff International Airways flight. After the war, numerous military pilots started flying companies, with one of them, the Flying Tiger Line, becoming the preeminent freight carrier. Robert Prescott, a former C-46 pilot who had flown in South Asia, started the company by purchasing war surplus airframes, including the Douglas C-47, and eventually obtaining a military contract to move supplies in the Pacific. Growth allowed it to expand into charter passenger transport and led to its use of the Super Constellation by the mid-1950s. In the following decade, it would extend cargo service by integrating with both rail and truck freight operations. In 1988, Flying Tiger Line merged with Federal Express. (Above, 1940 Air Terminal Museum; below, Briscoe Center for American History, University of Texas.)

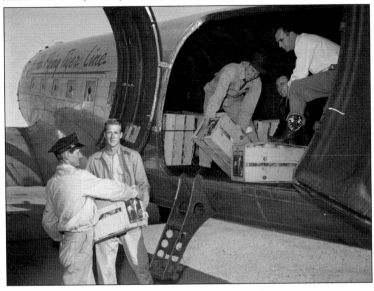

After World War II, the military wanted to retain the experience developed from four years of combat, and the Air National Guard became part of the solution to that objective. The 111th Tactical Reconnaissance Squadron was reestablished as the 111th Fighter Squadron and was assigned the F-51D Mustang as its operational aircraft. Above, a flight of the Guard's Mustangs flies past the battleship USS *Texas* (BB-35). Commissioned in 1914, her 14-inch guns provided fire support off of North Africa, Normandy, Iwo Jima, and Okinawa during World War II. In the decades following World War II, aircraft were privately restored in an attempt to extend the historical memory of the warbirds beyond simply a photograph, story, or static museum display. The restored SNJ-4 below at left with Vincent Tirado is in a Navy paint scheme, while the Piper L-4 (Cub) at right with Larry Karson is in the livery of a hack flown by the 12th Tactical Reconnaissance Squadron. (Above, Texas Military Forces Museum; below, Larry Karson.)

On March 6–8, 1949, William "Bill" Odom, working for Beech Aircraft, flew the Beech 35 Bonanza *Waikiki Beech* from Honolulu, Hawaii, to Teterboro, New Jersey, in 36 hours. Setting a nonstop record for light planes, Odom later flew the plane on a nationwide marketing tour for Beech. J.D. Reed, Houston Beech distributor and owner of *Beguine*, a highly modified P-51C, sold the warbird to the aviatrix Jacqueline Cochran (of racing and WASP fame) for Odom to fly in the upcoming Cleveland Air Races. Cochran planned to fly it later in the cross-country Bendix race. After winning the Sohio Trophy two days earlier, Odom raced in the closed-course Thompson Trophy event. On the second lap of the seven-turn pylon course, the P-51 went inverted, crashing into a home and killing three, including Odom. The accident, combined with the military's departure, contributed to the end of the Cleveland Air Races. Walter Beech, J.D. Reed, and Bill Odom are pictured below, from left to right. (Both, Briscoe Center for American History, University of Texas.)

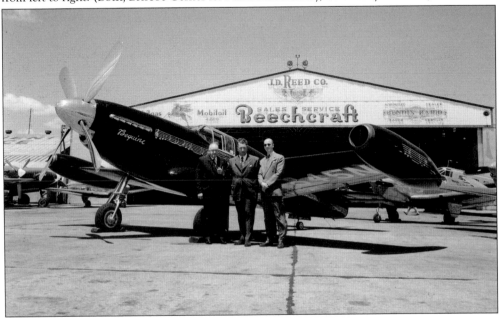

J.D. Reed, a former Hooper Oil Company corporate pilot and longtime friend of Walter and Olive Beech of Beech Aircraft fame, established a successful fixed-base operation and one of the country's first Beechcraft dealerships at Houston Municipal Airport. Reed also had facilities at Love Field at Dallas and the New Orleans Airport. Reed's interest extended to air racing, owning a variety of P-38s and P-51s in the postwar years. (Briscoe Center for American History, University of Texas.)

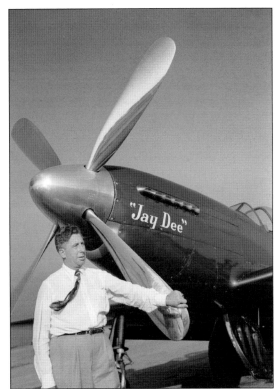

In 1947, J.D. Reed's two P-38s, *Sky Ranger* and *Green Hornet*, took second and third place respectively in the Sohio Trophy competition in Cleveland. His bronze-colored P-51D *Jay Dee* also competed in the 1949 Sohio Trophy Race. *Jay Dee* has since been restored to military livery and is on display at the Evergreen Aviation & Space Museum, the home of Hughes's eight-engine flying boat, the *Spruce Goose*. (Briscoe Center for American History, University of Texas.)

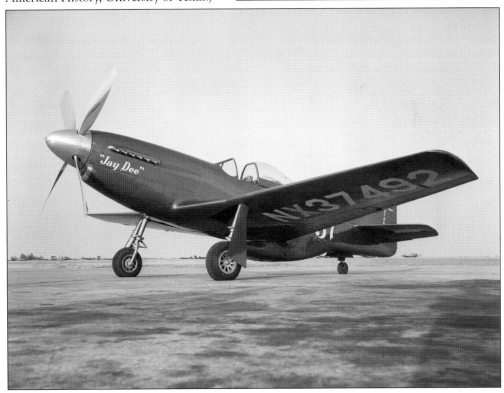

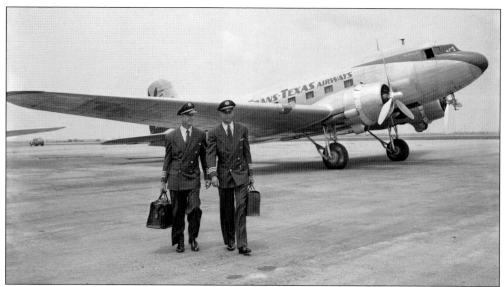

Trans-Texas Airways, originally founded as Aviation Enterprises Inc. in 1944, only to change its name three years later upon receipt of its CAB charter as a passenger airline, used 21-seat Douglas DC-3s to provide service to Dallas, San Antonio, and west to San Angelo. Within two years, Trans-Texas routes also extended west to El Paso and south to the lower Rio Grande Valley and included numerous smaller communities. For example, a 1952 route map shows service from Dallas, departing at 3:15 p.m., to Houston via Tyler, Palestine, Lufkin, Beaumont–Port Arthur, and Galveston, arriving at 6:34 p.m., and 56 minutes later, another flight departing Houston for Harlingen via Victoria, Beeville, Corpus Christi, Alice, and Mission-McAllen-Edinburg, arriving at 10:54 p.m. The low-altitude, short hops between airfields justly earned TTA the nickname of "Tree-Top Airlines." Early airlines mandated uniforms for pilots to enhance their prestige and to "sell flying to the public." Pan Am had led the way with its white caps and navy-blue double-breasted uniforms emulating the Navy. (Both, Briscoe Center for American History, University of Texas.)

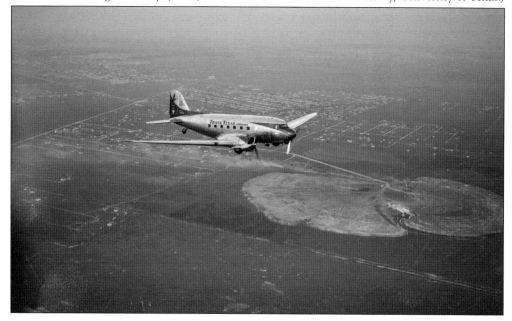

At the creation of Trans-Texas Airways, the original five DC-3s obtained from American Airlines were crewed from a cadre of 16 pilots and some five flight attendants. The early uniforms of stylized Western wear for the flight attendants (then known as stewardesses) reinforced the motif of Texas and the West. (Briscoe Center for American History, University of Texas.)

The earliest flight attendants date from the 1930s; the precursors to the position were found in maritime crews of the day. With duties that combined safety with service, some of the earliest female attendants were required to be nurses (United Airlines). With postwar growth, the nursing requirements were eliminated. (Briscoe Center for American History, University of Texas.)

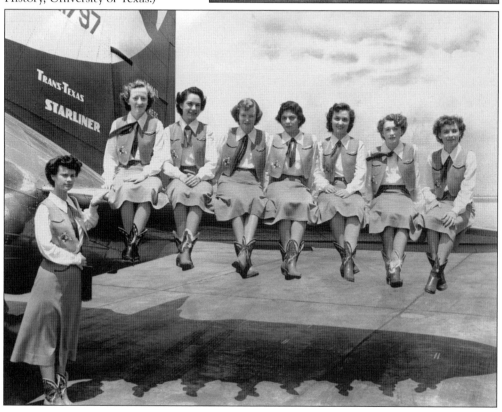

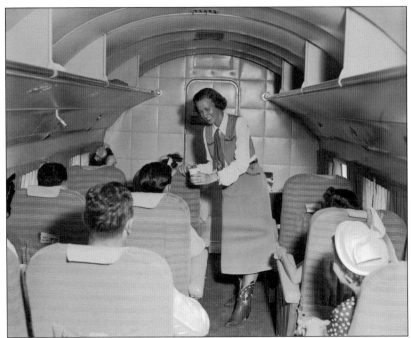

The accent on service is reflected in the above photograph. In the 1930s, Pan Am would only hire males for the position of steward, as much of the work was manual labor, such as handling baggage and assisting ground crews in mooring their transcontinental amphibious aircraft, but in later years, gender changed in the cabin as the hostess role came to the forefront. Many airlines limited cabin staff to unmarried women under the age of 32 or 35, depending on the carrier. Below, looking north, the TTA DC-3 is seen flying past downtown Houston. The distinctive Niels Esperson Building can be seen in the distance. (Both, Briscoe Center for American History, University of Texas.)

Five

THE 1950S AND BEYOND

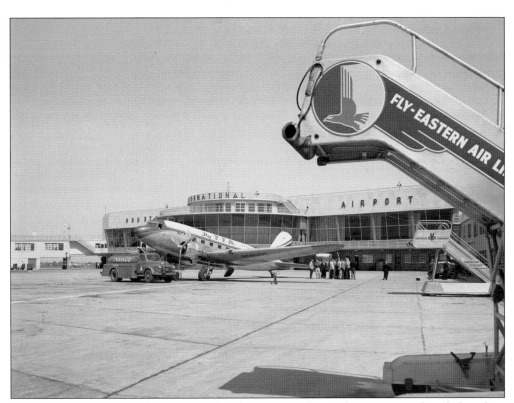

By the 1950s, Houston had grown out of its Art Deco–influenced 1940 terminal, and plans for a new state-of-the-art facility were implemented. Dedicated in November 1954, the new Houston International Airport terminal handled over 53,000 flights and one million passengers in the following year. In comparison, a decade previously, the airport had only 7,300 flights with 85,000 passengers. (Briscoe Center for American History, University of Texas.)

While press photographs tended to show flight crews in jackets, the reality for many during a Texas summer was a comfortable short-sleeved shirt. Trans-Texas Airways continued to operate Douglas DC-3s, marketed as Starliners, for the next two decades with Convair 240s and Beechcraft 99s later replacing the 20 DC-3s in the TTA fleet. By the end of the decade, Trans-Texas routes extended to Memphis across Arkansas and through Louisiana on to Jackson, Mississippi. Below, a DC-3 is parked at the Houston maintenance hangar of TTA. (Both, Briscoe Center for American History, University of Texas.)

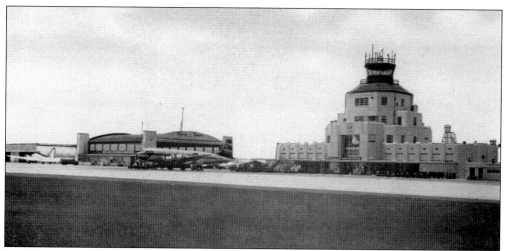

In 1950, the terminal at Houston Municipal Airport was enlarged, adding a floor immediately below the control tower. In the real-photo postcard above, one can compare the modified building to earlier photographs to see the difference. The sign above the entryway reads, "Houston International Gateway." Also shown are a Braniff DC-6 and a Douglas B-23 twin-engine bomber converted to executive transport parked in front of the Trans-Texas maintenance hangar. The B-23 Dragon was one of the aircraft owned by Howard Hughes. The composite photograph below shows the south side of the terminal with an International Arrivals wing added to the facility. Besides the superimposed Beechcraft D-18 in flight, utilized by an engineering firm in the 1950s, a Pan American Airways (Pan American World Airways since 1950) DC-4, *Clipper West Wind*, is gate-side. Formerly a military C-54 Skymaster acquired in 1947, she was operated by Pan Am until 1953. (Above, 1940 Air Terminal Museum; below, Story Sloan's Gallery.)

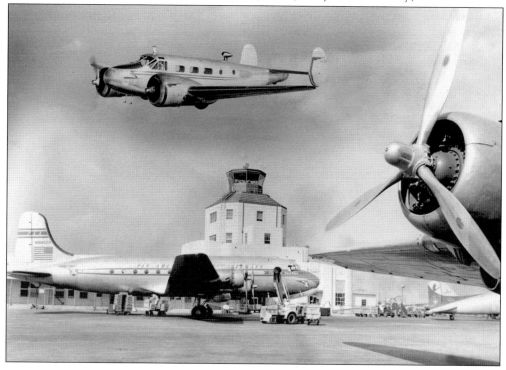

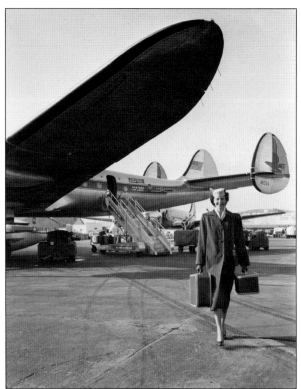

An Eastern Air Lines stewardess is departing N103A at Houston Municipal. The Lockheed Constellation, originally designed to compete with the Douglas DC-4, was first operated by Eastern in 1947. N103A, an early version of the Constellation, retired from Eastern service in 1961. In the left background, the logo of Slick Airways is visible on the front of one of the airfield buildings. Slick, a major cargo transport operation, flew from 1946 to 1966. (Briscoe Center for American History, University of Texas.)

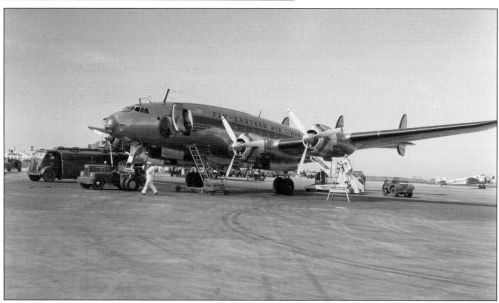

Another of the original Eastern Constellations, N104A, is shown at Houston Municipal with a variety of ground support equipment, including a Gulf Oil fuel truck providing service. By the late 1950s, Eastern was operating over 50 Connies, including more than three dozen of the improved L-1049 Super Constellations. The Lockheed 12 Electra Junior in the background is believed to be NC25624, a Humble Oil corporate aircraft. Continental Oil was also known to have operated an L-12. (MSS1220-1237-015, Houston Public Library, HMRC.)

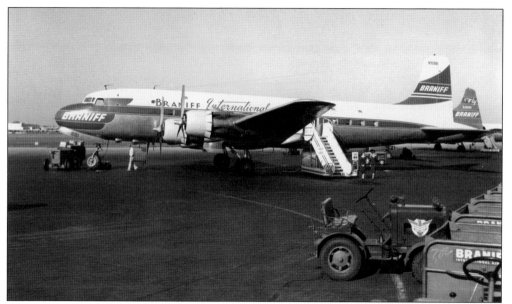

With the acquisition of international routes into Central and South America directly challenging Pan Am's supremacy in the region, Braniff Airways rebranded itself as Braniff International Airways in 1946. Using Havana as the gateway to South America, Braniff at one point found that the taxiway at Havana between its hangar and the runway had a trench dug across it by Pan Am employees to prevent runway access, as Pan Am considered the runway its corporate property. The 52 passenger Douglas DC-6 became Braniff's aircraft of choice for its *El Conquistador* service, providing berths for sleeping or "deep-cushioned lounge chairs." The paint scheme dates from the mid-1950s with the second Braniff aircraft in the rear still bearing the earlier "bare metal" livery. The tractor in the foreground carries the Continental Airlines "eagle" logo. (Above, MSS0157-0065, Houston Public Library, HMRC; below, 1940 Air Terminal Museum.)

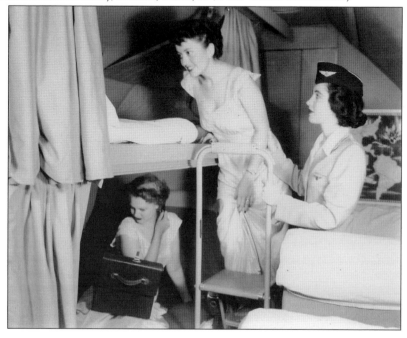

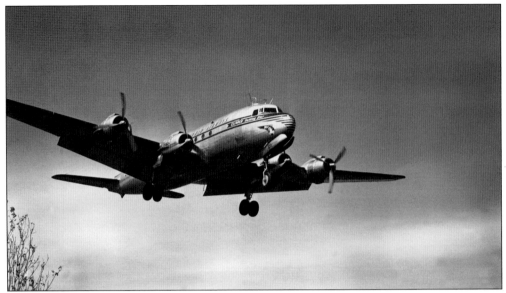

Pan American Airways operated out of Brownsville since early 1929, when it had been awarded a Foreign Air Mail Contract (FAM-8) between Brownsville and Mexico City. In 1946, Pan Am initiated international service directly from Houston to Mexico City using Douglas DC-4s. The *Clipper Guiding Star*, N88938, entered service in 1946, one of over 90 eventually in the fleet. With four Pratt & Whitney Twin Wasp engines of almost 1,500 horsepower each, the DC-4's 44 seats more than doubled the seating capacity of a DC-3's 21 seats, while having an operating range of 2,500 miles. In the decades prior to the DC-4, Pan Am had become an extension of American foreign policy, carrying the nation's flag throughout Central and South America, effectively preventing European carriers from successfully expanding into the Western Hemisphere prior to World War II. (Above, MSS 1220-1237002; below, MSS 1220-1237-14, Houston Public Library, HMRC.)

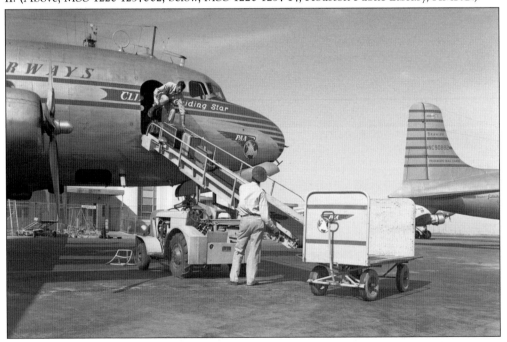

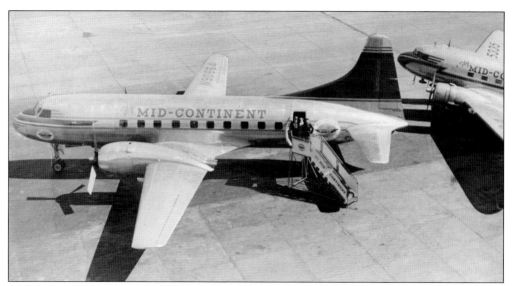

Mid-Continent Airlines expanded its fleet by adding four Convair CV-240s to supplement its DC-3s in 1950. They had a cruising speed of approximately 300 miles per hour compared to the 200 miles per hour of the DC-3, while also doubling seating capacity. Developed as a modern, pressurized airliner to serve the commercial airline feeder routes, the military also used various versions for passenger transport, cargo, and training missions. Over 1,000 were eventually built in numerous versions. Chicago and Southern also operated DC-4s out of Houston in the 1950s. In 1952, Mid-Continent merged with Braniff International Airways, with C&S merging with Delta Airlines the following year. Neither had routes strong enough to survive without a merger with a trunk airline. (Above, 1940 Air Terminal Museum; below, Briscoe Center for American History, University of Texas.)

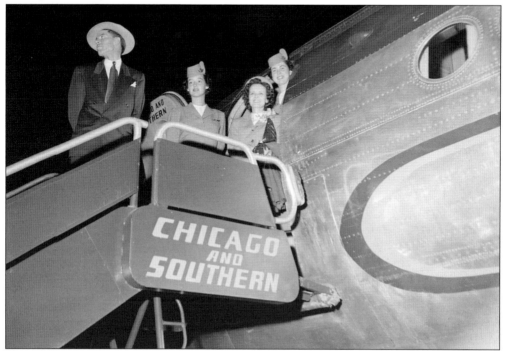

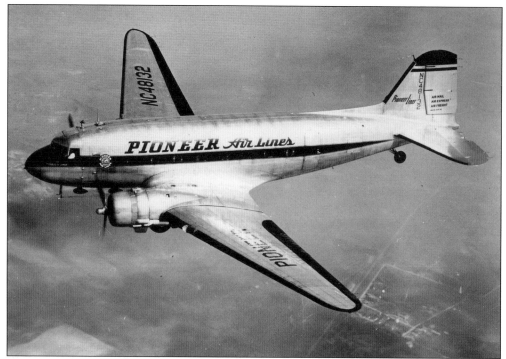

Pioneer Air Lines continued to operate until 1955, when Continental Airlines, based out of Denver, bought it. Continental operated primarily from Colorado east to Kansas and south to Texas—including Houston since 1950—and New Mexico, along with limited routes to the coast. Even with the acquisition of Pioneer, Continental's fleet was only one quarter the size of any of the Big Four airlines, each of which had approximately 200 aircraft in 1958. Also operating out of Houston Municipal Airport were the F-80s of the Air National Guard's 111th Fighter Squadron. After service in the Korean War, the squadron returned to Houston and was assigned the Lockheed F-80 Shooting Stars, becoming a Fighter-Interceptor Squadron. The squadron insignia is visible on the left side of the nose of the center aircraft below. (Both, 1940 Air Terminal Museum.)

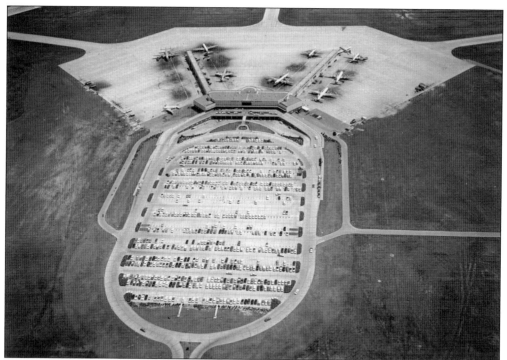

In late 1954, the new Houston International Airport terminal was dedicated, opening for service six months later. Built on the north end of the airfield property, the terminal had ample parking for the period, and unlike the simple design of the earlier terminals, it featured two concourses in the "pier finger" configuration common in the 1950s. A third concourse was added in 1961. The airport was renamed in 1967 after the former governor of Texas and owner of the *Houston Post* newspaper, William P. Hobby, who had died three years previously. With the further development of the airport, the runways themselves were once again repaved; years earlier, the original crushed shell runways had been paved to accommodate heavier commercial and military aircraft. (Above, 1940 Air Terminal Museum; below, Briscoe Center for American History, University of Texas.)

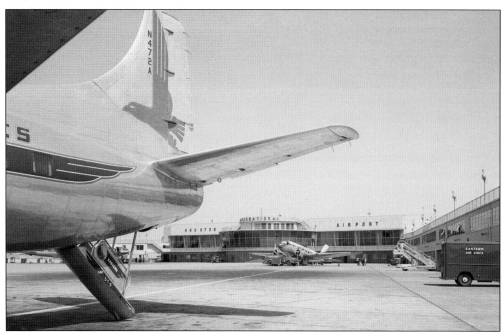

Airlines serving Houston International Airport in the mid-1950s included Braniff International, Eastern, Pan American, Trans-Texas Airways, American, Continental, Delta, and National Airlines (service initiated in 1956). The Martin 4-0-4 of Eastern in the foreground was bound for San Antonio after having arrived from Baton Rouge by way of LaFayette–New Iberia, Lake Charles, and Beaumont–Port Arthur. A Braniff DC-6, N90886, is in the background, while a Trans-Texas DC-3, N18105—a former United Airlines DST originally equipped with sleeping berths—is refueling. Careful examination of the night interior photograph of the new terminal below reveals one person reading a newspaper and at least three sleeping on couches under the windows to the left. (Both, Briscoe Center for American History, University of Texas.)

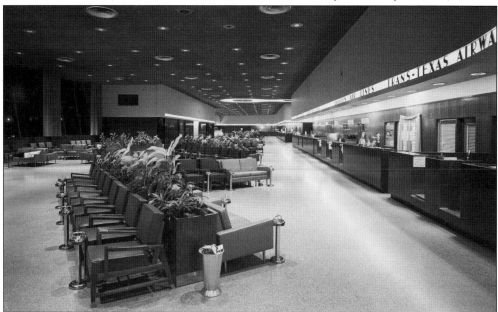

KLM Royal Dutch Airlines, Houston's oldest foreign air carrier, inaugurated the first European service to Houston in 1957 with its Douglas DC-7C flights from Amsterdam by way of Montreal with continuing service to Mexico City. KLM, flying since 1920, developed a hub-and-spoke operational system centered in Amsterdam with its routes developing across the European continent. It eventually merged with Air France in 2004. Here, a family pauses upon arrival at Houston. Air France started service from Houston to Paris in 1962 with Boeing 707s. (Briscoe Center for American History, University of Texas.)

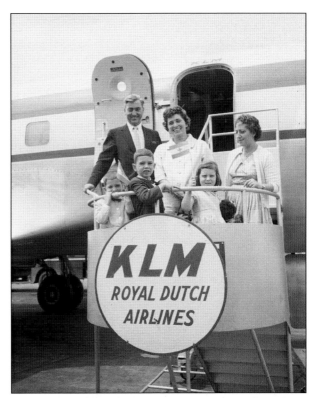

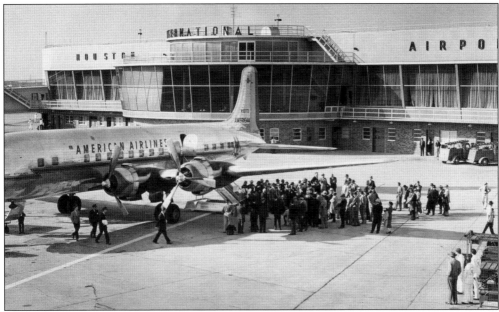

American Airlines served Houston sporadically during the 1930s, but was no longer providing service in the 1940s. It later reentered the market through interchange agreements with Braniff. After being awarded new routes of its own, American utilized DC-6s, such as the *Flagship Pittsburgh*, N90773, for service between New York and Houston as well as between Houston and the Pacific coast. (1940 Air Terminal Museum.)

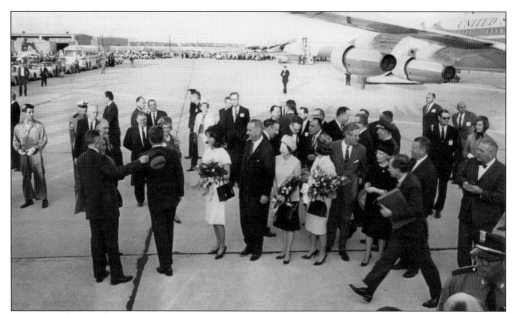

In September 1962, Pres. John F. Kennedy gave his iconic "moon speech" at Rice University, calling on America to put a man on the moon by the end of the decade. The following year, on November 21, 1963, President Kennedy returned to Houston for a testimonial dinner at the Rice Hotel, departing that evening for Fort Worth. President Kennedy flew to Houston in Air Force One, a new Boeing C-137 Stratoliner—a highly modified 707 identified as Special Air Mission 26000. Raymond Loewy, the designer of the interior of Howard Hughes's personal Boeing 307 Stratoliner, had designed the paint scheme for the presidential aircraft. The day after visiting Houston, President Kennedy was assassinated in Dallas. Vice Pres. Lyndon Baines Johnson took the presidential oath of office on board Air Force One immediately after the assassination, returning to Washington with the First Lady and President Kennedy's remains. (Above, MSS0414-0340; below, MSS0414-0350, Houston Public Library, HMRC.)

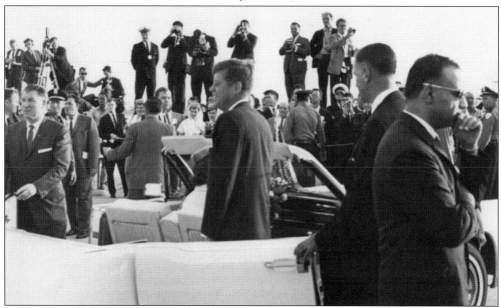

Trans-Texas Airways stewardesses were no longer modeling Western wear as conservative service-oriented uniforms were the norm in the industry in the early 1960s. That would change with Braniff retaining Italian designer Emilio Pucci to create eye-catching uniforms. Other airlines soon followed with Oleg Cassini (National), Jean Louis (United), and Pierre Balmain (TWA) designing each airline's respective cabin crew wardrobe. (1940 Air Terminal Museum.)

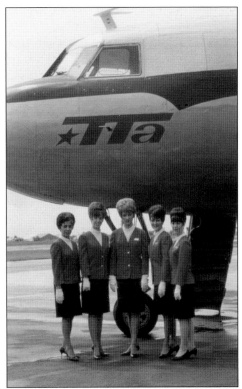

Trans-Texas Airways bought 25 Convair 240s from American Airlines, the first entering service with TTA in 1961. By 1966, the 240s were converted in-house to turbo-props, marketed as prop-jets, by installing Rolls-Royce Dart engines in the Convairs. By the end of the year, TTA was also flying Douglas DC-9 jet aircraft, recognizing that the traveling public all but expected "pure" jets even on the shortest routes. TTA became Texas International Airlines in 1968, later purchasing Continental Airlines in 1982 and retaining the Continental name. TTA was no more. (1940 Air Terminal Museum.)

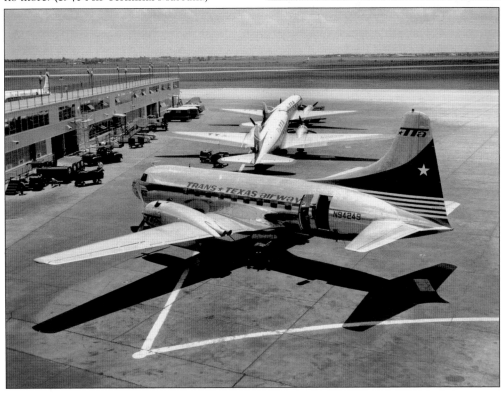

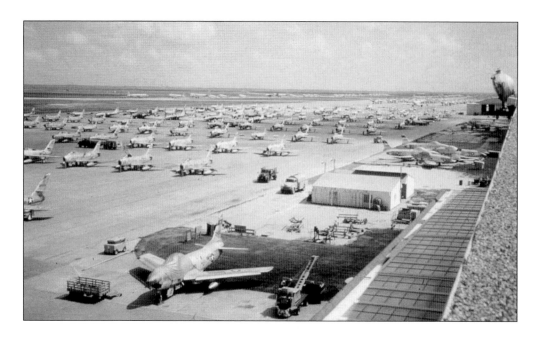

While commercial carriers were still pushing prop-engine planes through the skies, the military were flying jet-powered aircraft worldwide. In 1960, F-86 fighters from across the nation flew into Ellington Field for an Air Force conference. Numerous F-86A Sabres are seen on the tarmac while an F-86D Sabre Dog all-weather interceptor is shown in the foreground covered in canvas. The F-86 was used in the Korean War, successfully challenging the Soviet MIG-15. The F-86 entered Air National Guard service in the late 1950s, with the Texas ANG, including the 111th Fighter-Interceptor Squadron at Ellington, operating them from 1957 to 1960. Used as an advanced trainer and developed from the P/F-80, the Lockheed T-33 Shooting Star was also assigned to Air National Guard units operating F-101 or F-102 interceptors as proficiency trainers. (Above, 1940 Air Terminal Museum; below, Boyd Wachter.)

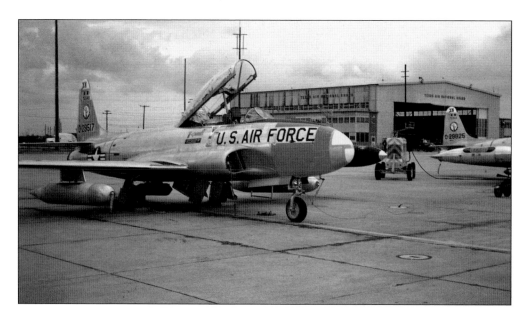

A Convair F-102 Delta Dagger and a McDonnell F-101 Voodoo aircraft are seen over the San Jacinto Monument. The horizontal bar above the Ace-in-the-Hole insignia on the F-102 is the Air Force Outstanding Unit Award conferred on units that have "distinguished themselves by exceptionally meritorious service or outstanding achievement that clearly sets the unit above and apart from similar units." The F-101s were assigned to Ellington in 1971 for service with the Combat Crew Training School. From flying F-80s and later F-86s, the 111th Fighter-Interceptor Squadron, part of the 147th Fighter Group (Air Defense), transitioned to F-102s in 1960, along with assuming 24-hour alert duty, which provided the Texas Gulf Coast with air defense capabilities. The vertical stabilizers of the two Delta Daggers in the hangar below also show the Ace-in-the-Hole insignia. Comprised of a gold Lone Star with an ace of diamonds tucked into the center, its use dates back prior to World War II. (Both, Texas Military Forces Museum.)

Houston's Intercontinental Airport

By 1957, it was recognized that Houston International would not be able to handle the forecasted aviation traffic, leading business and civic leaders to develop a new site north of Houston. Originally known as Jetero, the dedication of Houston Intercontinental Airport would not take place until June 1969, though the first runway was completed in 1964. A variety of designs were imagined, including the hub-and-spoke layout shown above; eventually, two individual terminals were completed. Commercial operations shifted from Houston International, renamed William P. Hobby Airport two years earlier, to the new IAH (later renamed George Bush Intercontinental Airport). With the loss of the airlines, Hobby's future came into question until startup Southwest Airlines initiated service from Hobby to Dallas and San Antonio in 1971. Southwest now serves as the anchor of Hobby, returning international commercial air service to the historic airfield. (Both, 1940 Air Terminal Museum.)

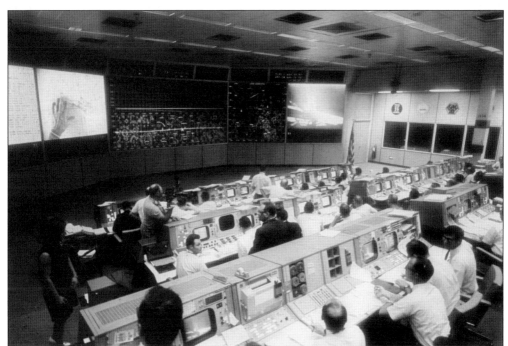

On July 20, 1969, Neil Armstrong and Edwin R. "Buzz" Aldrin became the first men to land on the moon. This achievement, accomplished with Michael Collins as the Command Module *Columbia* pilot, represented the culmination of a national effort to explore space. While contributions from across the nation played a role in the successful Apollo lunar program, much of the space program was focused in Houston. The Mission Control Center at Houston, part of the Manned Spacecraft Center, was responsible for coordinating and monitoring manned space flights. Mission Control Center Room No. 2, the facility used for the Apollo 11 moon landing, is now designated a National Historic Landmark and is listed in the National Register of Historic Places. In less than 60 years, Houston had seen an aviator circling a pasture a few hundred feet off the ground to sending three astronauts to the moon and hearing the words proclaiming success: "Houston . . . the *Eagle* has landed." (Both, NASA.)

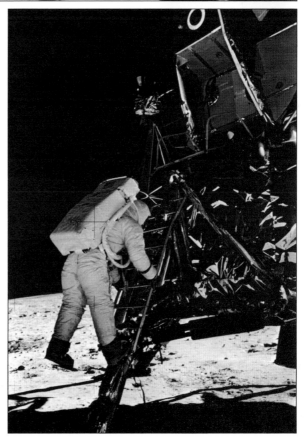

BIBLIOGRAPHY

Bilstein, Roger, and Jay Miller. *Aviation in Texas*. Austin, TX: Texas Monthly Press, 1985.

Carlson, Erik. *Ellington Field: A Short History, 1917–1963*. Houston, TX: NASA, 1999.

Davies, R.E.G. *Airlines of the United States since 1914*. London, UK: Putnam, 1972.

———. *Pan Am: An Airline and its Aircraft*. New York, NY: Orion Books, 1987.

Eden, Paul, and Soph Moeng, eds. *The Complete Encyclopedia of World Aircraft*. New York, NY: Barnes & Noble, 2002.

Ganson, Barbara. *Texas Takes Wing: A Century of Flight in the Lone Star State*. Austin, TX: University of Texas Press, 2014.

Grossnick, Roy A. *Kite Balloons to Airships: the Navy's Lighter-than-Air Experience*. Washington, DC: Deputy Chief of Naval Operations (Air Warfare) and the Commander, Naval Air Systems Command, 1987.

Hansen, Al. "Aviation Division of The Texas Company: Part 1, 1928–1945." *American Aviation Historical Society Journal* (Spring 2003): 36–43.

———. "Aviation Operations of Standard Oil Corporation and Affiliates, 1919–1941." *American Aviation Historical Society Journal* (Summer 2003): 114–122.

Holden, Henry M. *The Legacy of the DC-3*. Niceville, FL: Wind Canyon Publishing, 1997.

Ivie, Tom. *Aerial Reconnaissance: The 10th Photo Recon Group in World War II*. Fallbrook, CA: Aero Publishers, 1981.

Maurer, Maurer. *Aviation in the U.S. Army, 1919–1939*. Washington, DC: US Air Force, 1986.

Newlan, Ralph. *Texas General Aviation*. Austin, TX: Texas Department of Transportation, 2008.

Robinson, Anthony. *Dictionary of Aviation: An Illustrated History of the Airplane*. New York, NY: Crescent Books, 1984.

Stringer, David H. "America's Local Service Airlines, Part V—Southern Airways, Trans-Texas Airways, West Coast Airlines." *American Aviation Historical Society Journal* (Winter 2013): 248–270.

Texas State Historical Association. *The Handbook of Texas Online*. www.tshaonline.org/handbook/online.

About the Organization

The 1940 Air Terminal Museum is the d/b/a of Houston Aeronautical Heritage Society Inc., a 501(c)(3) nonprofit corporation founded in 1998 to preserve and restore the beautiful Art Deco Houston Municipal Airport Terminal and to operate within it a museum of civil aviation. The museum collects, preserves, and interprets the aviation history of Houston and the surrounding region; it makes museum holdings and information accessible to the public and engages in and encourages study and educational use of its collections.

Noted local architect Joseph Finger designed the terminal, situated on the west side of present-day William P. Hobby Airport, in 1938. It was constructed during 1939–1940 with funding from the Public Works Administration and opened on September 28, 1940. Locally significant as one of the most elegant, distinctive, and accessible historic buildings in Houston, it is nationally significant as one of the few remaining examples of Streamline Moderne–style airport architecture from the Golden Age of Aviation.

The terminal will be 75 years old during 2015. It is a registered City of Houston Landmark. It was designated a Historic Aerospace Site by the American Institute of Aeronautics and Astronautics in 2009. The society's restoration effort received the Gold Brick Award from Preservation Houston in 2010.

The ground floor of the terminal is open to the public. Additional restoration is required to open the upper floors. Gifts to the museum are tax deductible and help us to perform our mission to preserve history and provide a platform for lifelong learning. Please support us online at shop.1940airterminal.org.

DISCOVER THOUSANDS OF LOCAL HISTORY BOOKS FEATURING MILLIONS OF VINTAGE IMAGES

Arcadia Publishing, the leading local history publisher in the United States, is committed to making history accessible and meaningful through publishing books that celebrate and preserve the heritage of America's people and places.

Find more books like this at
www.arcadiapublishing.com

Search for your hometown history, your old stomping grounds, and even your favorite sports team.